picturing

GREENSBORO

Picturing

GREENSBORO

*Four Decades of
African American Community*

Otis L. Hairston Jr.

Charleston London

History
PRESS

Published by The History Press
Charleston, SC 29403
www.historypress.net

Front cover image: Biracial discussions in 1970s Greensboro, organized by the Greensboro
Chamber of Commerce's Community Unity Division.
All images courtesy of the author unless otherwise noted.

First published 2007

Manufactured in the United Kingdom

ISBN 978.1.59629.284.0

Library of Congress CIP data applied for.

Contents

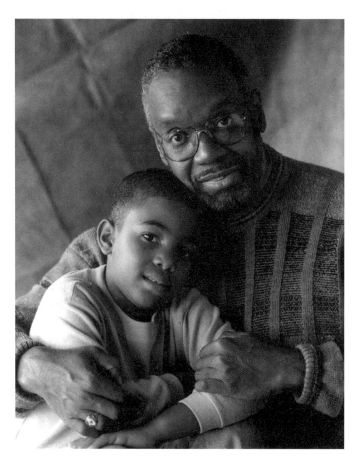

Otis and Sidney Hairston.

Acknowledgements

My greatest thanks go to:

Warren "Sidney" Hairston, my son, who was my motivation and source of strength for completing this book. Sidney, I love you and am so proud of your accomplishments. You are a wonderful, rare child with no comparison. Being blessed with you has been my treasure.

Know that there aren't any shortcuts to tomorrow. You have to make your own way. It isn't always easy. It takes a strong spirit, an open mind and a willing heart. You have all of those and more. Life isn't days and years ut it's what you do with time and all the goodness that's inside you. Stay centered and focused with the knowledge that your strength is from the Creator.

Special thanks to those who took a moment to quote their experiences and discuss their knowledge of the images included in this book. It has provided the reader with a greater knowledge and depth of understanding of the "real story" of these images.

Also, a special thanks to Lee Handford, my editor, who showed remarkable patience and understanding in the many obstacles that arose during the publication of this book. Thanks for your ideas and guidance, which greatly enhanced the quality of the book.

Lastly, let me thank my family for their encouragement, and not the least my Creator who provided me with the mental, emotional and physical strength for completion of this publication. At times it was a challenge, but with my faith I know that "all things are possible."

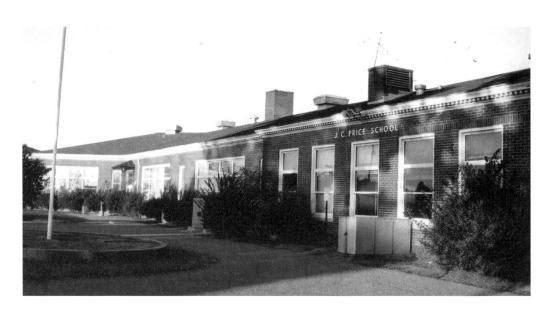

J.C. Price School.

Introduction

As I began my career in photography in 1971, it was also the period of school integration in many southern school districts. My alma mater, Dudley High School, along with many of the African American majority neighborhood schools, was impacted by the desegregation of our local school system. Many schools in the African American community were closed, and students in these communities were bused to schools in the white communities to achieve so-called "equal education." One of these schools, historic J.C. Price School, is being threatened now with destruction as Greensboro College, a private college in the Greensboro community, has plans to build a sports complex in the center of the historic Warnersville community where I now reside.

The threat to J.C. Price is significant, and images in this book reflect on much of the historic traditions and events in the African American community that have been lost due to a lack of effort by past and present generations to preserve our past. Johnny and Brenda Hodge's following statement makes this very clear:

In the very near future, a decision will be made whether to preserve or demolish J.C. Price School. The sad part about this issue is that few Guilford County citizens understand the historical significance of this location.

People in this area need to be informed about the contributions that J.C. Price School (and other segregated schools) made to the growth of public education in America. It is only by gaining sufficient knowledge and thorough insight that communities are able to make wise decisions about what can be destroyed and what should be preserved.

We've heard on numerous occasions that "You can't appreciate your present unless you know something of your past."

This statement becomes particularly meaningful to those of us whose roots trace back to the old Warnersville community. In an age characterized by financial, social and moral degradation, many of our black youth are finding it more and more difficult to find worthwhile connections to black history in Greensboro.

Never before in the history of this country have so many young black youth lost sight of what education and knowledge has meant for our race. Not only has there been a decline in their test scores, but their respect for education and leadership has come to an alarming halt. These problems are amplified by the fact that, over the past thirty years, black people in leadership roles have

been carefully deleted from public school systems. Many blacks have been replaced by others who know little, if anything, about the motivations, the achievements and the struggles of our ancestors.

J.C. Price School sits in the middle of the old Warnersville community where there are precious few reminders of the history of black people in Greensboro. Warnersville was the first black community in this county where people of color could own their own homes, build their own churches, own land, run their own businesses and educate their own children. J.C. Price served an important cultural function for children and adults who belonged to an authentic cultural minority.

Most often a teacher's appointment to a position at J.C. Price implied that the teacher was highly trained. They were considered by many to be the best in the field. Some of these teachers received their training in Guilford County, attended colleges and universities throughout the United States and often found their way back to J.C. Price to teach. Thus, the legacy was passed on; the people progressed.

Consider the contributions of the longtime Price principal, A.H. Peeler. Said one former Price student:

"During the 1950s few would dispute that Negroes were getting education inferior in quality to that provided for whites. Mr. Peeler never emphasized our lack. He always accentuated the positive and he expected a lot from us. Our industrial arts department, our home economics department and our library were second to none in the state. We were pushed to excel and we were motivated to always do our best...that's the way Mr. Peeler was. And, most importantly, our parents trusted him."

Said Mr. Peeler:

"I was born in Warnersville. My mother taught at the J.C. Price School. Our children attended J.C. Price School. It was my privilege to serve as principal of J.C. Price for thirty-nine years. I belong to this community and J.C. Price belongs to us."

The 1970s

Civic Leader Cynthia Doyle and Race Relations Activist David Richmond (center) were among more than four thousand Greensboro citizens who participated in weekly discussion cell meetings between 1966 and 1972. The six-year program was designed to improve community support and acceptance of interracial activity, including school desegregation. The meetings were organized by the Greensboro Chamber of Commerce's Community Unity Division, headed by Rev. Cecil Bishop, Al Lineberry Sr., Rev. Otis Hairston, Margaret Earle, Hal Sieber, Harold Lanier and others.

—Hal Sieber

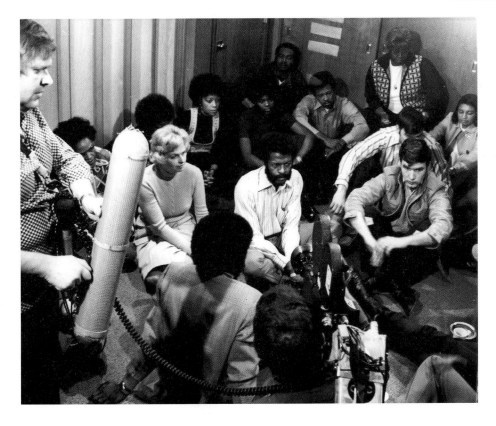

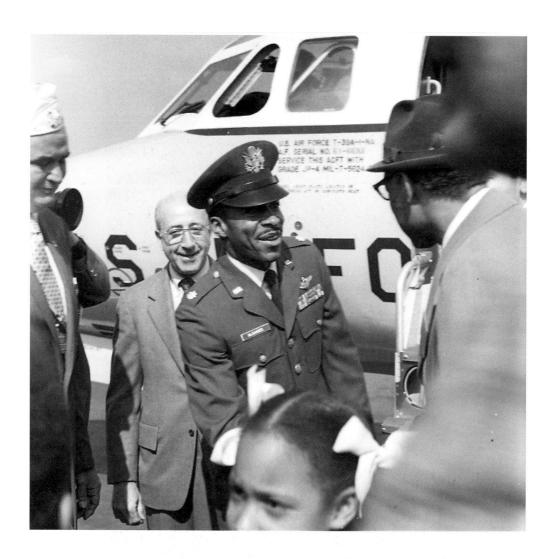

After seven years away from home (February 1966–February 1973) then Major Norman A. McDaniel, United States Air Force, returned to Greensboro in his home state of North Carolina. He arrived at the airport from Andrews Air Force Base where he had spent two weeks in debriefings and medical exams following his ordeal as a prisoner of war in North Vietnam for over six and a half years.

As I speak to the crowd and news media, I'm thinking, "What a great day, what a blessed day!" I'm finally home again after seven years away from my wife, children, other relatives and friends. I'm back in good old North Carolina, my home state. It feels good to be talking to friends instead of being interrogated by the enemy and fearing that I will be subjected to torture at any moment. As I answer the news media's questions, I thank God again that my wife, son and daughter are by my side.

—Colonel Norman McDaniel, Aggie 1957

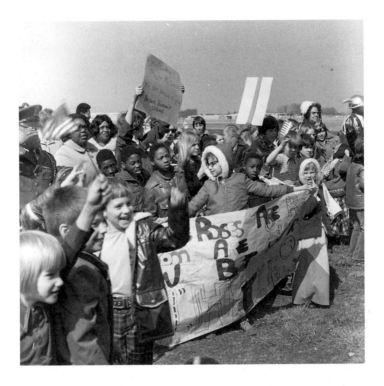

POW Major Norman McDaniel returns home.

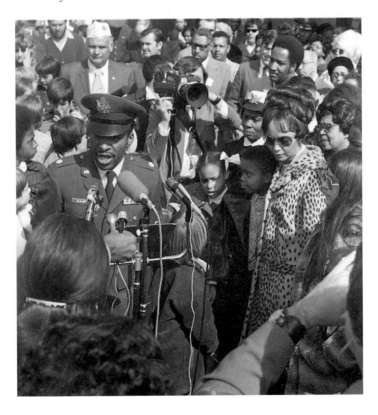

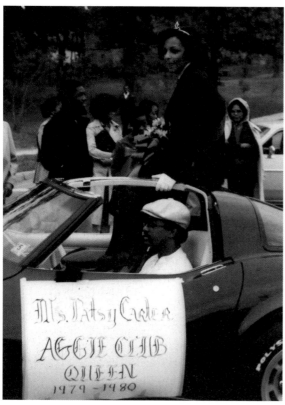

Miss Aggie Club.

I accepted the challenge to compete as Miss Aggie Club because of the cause to help the athletic program. I competed against three other ladies by having cake sales, car washes and asking for donations through a letter. During the competition, I met a lot of the members of the club and learned some of the history of the Aggie Club. I won the contest and rode in the homecoming parade as the queen and also received a small monetary donation from the competition.

The Aggie Club was started in the early sixties by several local gentlemen, Richard Moore, Sandy McLendon, Willie Jeffries, Carl Manuel Sr. and Ellis Corbett, for whom the campus gym is named.

I will always support the Aggie Club as long as their mission stays the same, supporting Aggie athletes.

—*Patsy Frazelle*

Greensboro, North Carolina, especially North Carolina A&T State University, comprises my canvas. In addition to sharing my experiences in the realm of health education and athletics, full expression of what it seems that God meant for me to do is found in coaching football.

I enjoy the challenge of taking young athletes through the level of their own discovery of their ability and fostering their outlook on life itself. To feel the thrill of being a part of the development of the life and character of groups of young men is unique fulfillment of my reason for being.

—*Dr. Bert C. Piggott*

Coach Piggott.

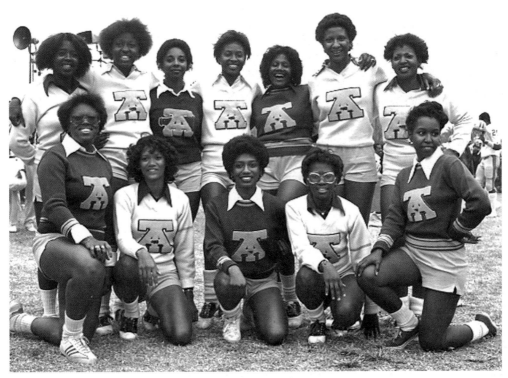

Alumni cheerleaders.

North Carolina A&T State University has been a part of my life for as long as I can remember. Born and raised in Greensboro, cheering for A&T was always one of my desires. As a child in the '60s, I witnessed the entire Moore Gymnasium chanting "I Got that Feeling," led by Shirley Dean from Philadelphia. The spirit would be all over the body from head to toe. The crowd would repeat after her lead. The Aggie opponents had no chance of getting out of there with a win. Also, in the '60s, the Aggies played in the Greensboro Coliseum and the echoes of "Let's go Aggies" ignited the team to play harder. The cheerleaders were part of the game.

My four years (1971–75) as a cheerleader were exciting because of the many successful seasons by the Aggies. In 1972–73, cheerleaders such as Aona Jefferson and others would come back to War Memorial Stadium for Homecoming. They circled up with us and jumped, cheered to the crowd and performed dance routines. This was the beginning of the Alumni Cheerleaders. There are currently more than one hundred alumni cheerleaders.

—*Cassandra Nash Watkins*

When I participated in the "Miss Black America of Greensboro Pageant," I was a nineteen-year-old junior at Bennett College. As I reflect on that experience, the phrase that I would use to describe my experience as a contestant is "Rite of Passage." Not only did I lose forty pounds in preparation for the pageant, I learned a great deal of information about being a lady by participating in the pageant that has proved invaluable to me over the years. I clearly remember my friend, Jennifer Wells, who relentlessly encouraged me to participate in the pageant for the experience and for Charlotte Stewart, who accompanied me on the piano during my performance. The pageant's motto has proved true over and over in my life: "If you sow the seeds of positivity, you'll reap the flowers of success." In the years that have followed, God has been very good to me.

—Irene Chavis Evans

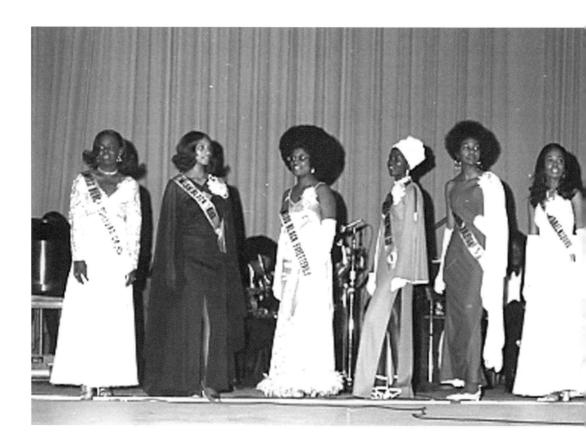

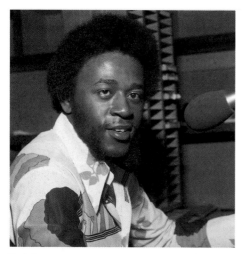

Bob Jones.

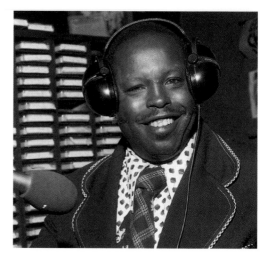

Alfred G.

1510-WEAL

I first started working at 1510-WEAL in 1968. I worked with Merle Watson, Prince Ike, Alfred G., Slick Slack, Billy Brooks and several other announcers. I learned quickly that radio was about personality. I graduated from A&T in January 1969 and left to do a four-year hitch in the U.S. Air Force.

I returned to work at WEAL in the mid-70s. I worked with Gil Harris, Ty Miller, Lamar Capel, Bob Jones and others. Radio was still about personality, but the music was equally important. Listeners had access to their music in other forms like 8-track players and FM radio.

News and information were important elements of radio. We had SBN network news, and we had a local talk show called Sounder. It was originally hosted by Gil Harris and a young Caucasian lady named Lea Miller. Ty Miller and I hosted the show through the late 70s and early 80s. Our shows became more important immediately after the 1979 Klan-Nazi incident. Our lives were threatened many times because of the live comments made on Sounder. Unfortunately, the threats were coming from black people who did not agree with our need as announcers to maintain control of our show.

During the late 70s the people who owned WEAL switched their adult contemporary station WQMG-FM over to a black music format. WQMG-FM offered no community affairs programming and very little news. The news it offered was not geared to the black community. That move spelled the end of news information and community awareness for the black community in Greensboro. In my opinion, the quality of life, health and our neighborhoods, and respect for one another in the black community, have deteriorated since we have moved away from community based stations.

—Tony Welborne

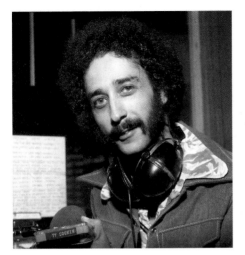

Ty Miller.

Lea Miller.

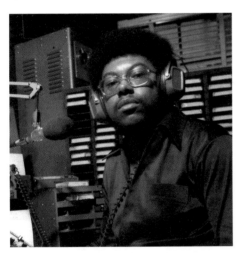

Tony B.

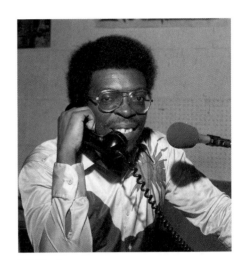

Gil Harris.

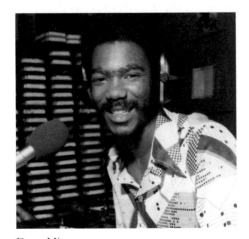

Doug Minor.

Mike Cole.

The Aggie Alumni Band Association (The Alumni Band) was founded by former A&T band member, James Nimrod Perry (deceased), Ronald Cooper, Bobby Pickens and Jean Wilson, with the assistance of J.J. Williams, assistant band director. Since its inception during the mid-70s, the group has grown from a small one of dedicated alumni band members to a uniformed and popular 150-plus-piece marching and playing unit in A&T's homecoming parade. Members are band alumni from the late '50s through 2007. In addition to Homecoming participation, the organization provided assistance and support to the university band.

—Crystal Stroud McCombs

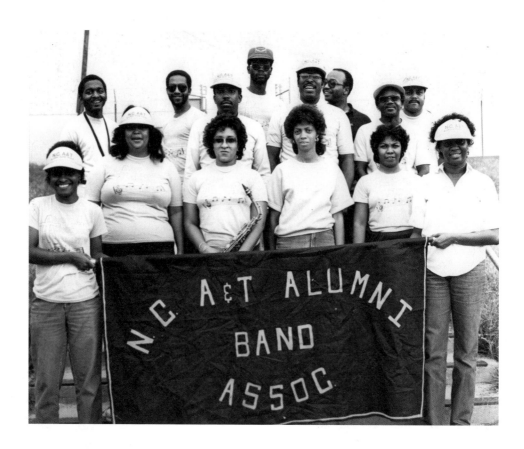

Above: The original Aggie Alumni Band.
Opposite above: Alumni majorettes performing at Homecoming.
Opposite below: 1984 Alumni Band.

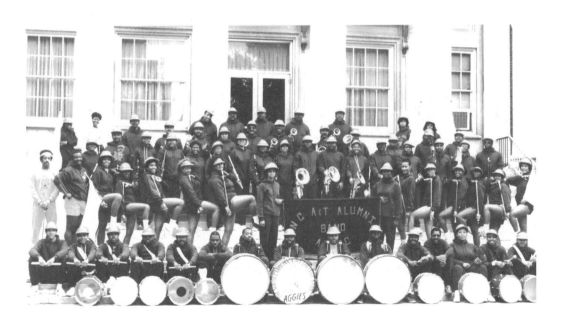

Looking Back:
Homecoming during the 1970s at North Carolina A&T State University

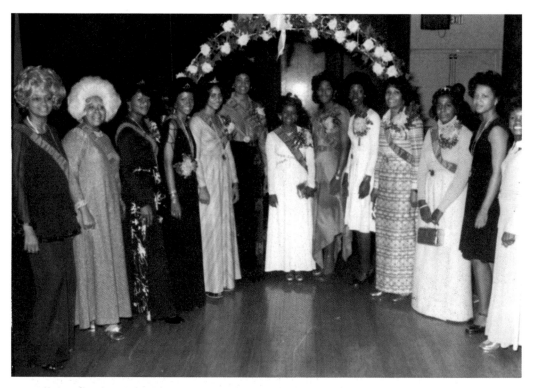

Miss Alumni queen and contestants.

Preparing for homecoming at A&T during the '70s was always an exciting and special time for Aggies and the Greensboro community. You could "smell it in the air."

On campus the queens had been chosen—Miss A&T, Miss Alumni, Miss Gate City, sorority and fraternity queens, ROTC queens and other organization queens. The community was eager to be a part of the mile-long Aggie Homecoming Parade. There are organizations, churches, drill teams, motorcycles, horses, beautiful floats and decorated cars and bands. I was privileged to wear the title "Miss Gate City Alumni" in 1973–74.

The streets were lined with Aggies from near and far. They were dressed for a fashion show. The Greensboro community became a part of the Aggie Family, showing their love for the Aggies. Everyone looked forward to seeing the performance of the Aggie Marching Band under the direction of Walter Carlson, J.J. Williams and Johnny Hodge. The precision, the high-stepping, fantastic sounds and drumbeats were unmatched in collegiate bands.

Vendors surrounded memorial stadium, selling hot dogs, burgers, chicken and fish, with the smell of chitterlings filling the air.

The homecoming game at Memorial Stadium was filled with standing room only crowds. Spectators walked from side to side showcasing their fashions and greeting old classmates. The

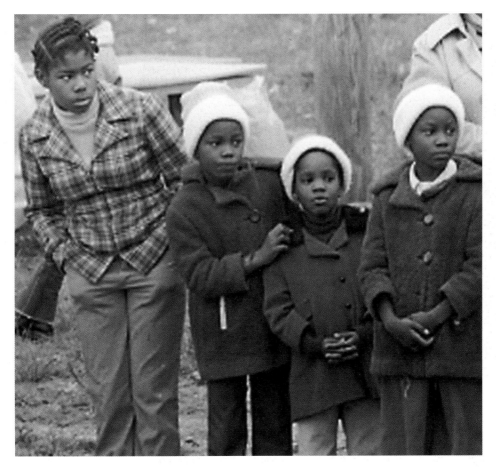

Kids watching homecoming parade.

game was always very competitive and the Aggies almost always prevailed victoriously with coaches like Hornsby Howell, "Big Ten" Groomes, Willie Jeffries, Murray Neely and Aggie stars such as Dwayne Board, Al Holland, George Ragsdale, Elsworth Turner and George Small, to name a few. The queens, Hall of Famers, Aggie alumni, students, the band, cheerleaders, drill teams, the Soul Food dinners, parade, dances, vendors—all set the foundation for what is now known as "The Greatest Homecoming on Earth!"

—Sandra Cook

Marvin Gaye at Aggie football practice.

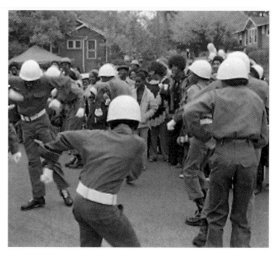

ROTC Drill Team.

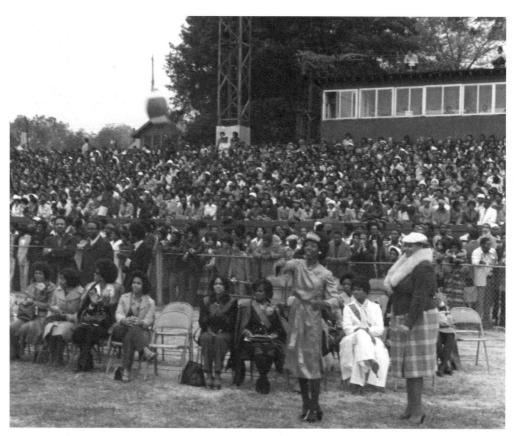

Pre-Game Show.

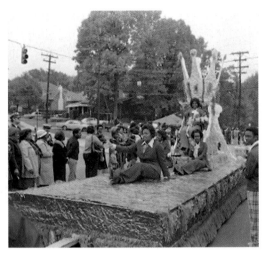

Miss A&T and her court.

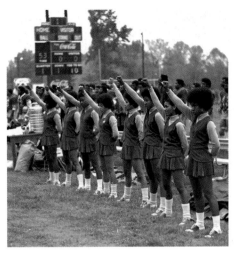

Aggie cheerleaders.

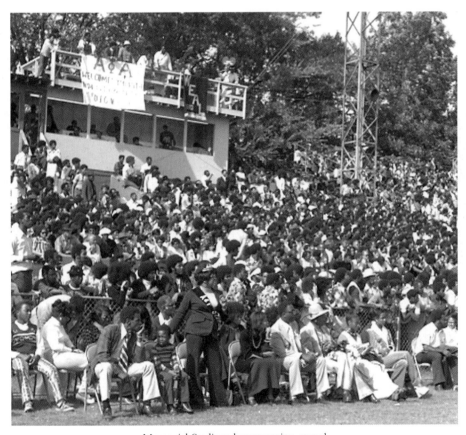

Memorial Stadium homecoming crowd.

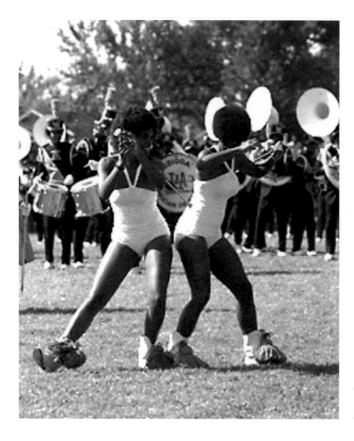

Left: The "Bump."

Below: Homecoming Game action.

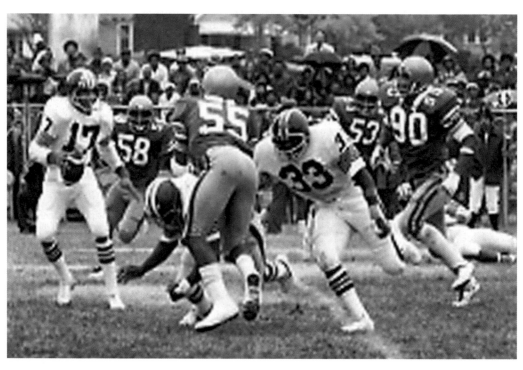

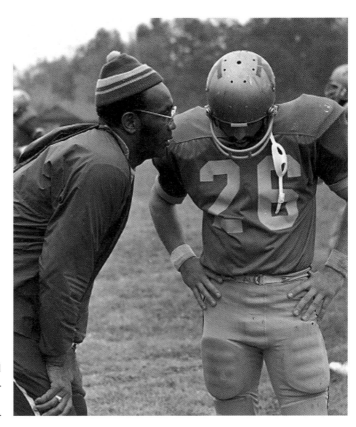

Right: Coach Howell with Al Holland.

Below: Aggie coaches.

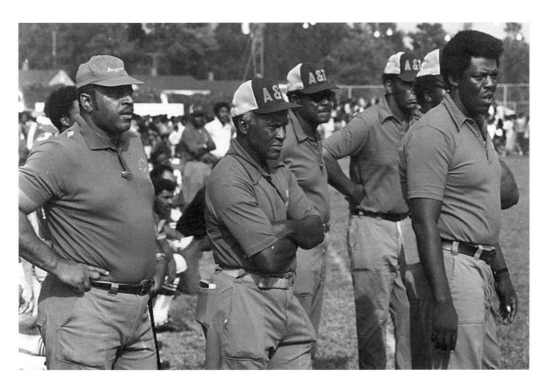

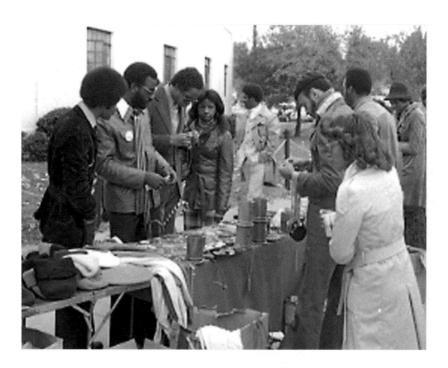

Above: Aggie vendors.

Below: "The Party."

Miss Black North Carolina.

It was thirty years ago and yet I can remember standing and smiling for what seemed to be hours as the judges were making their final decision. Winning that night provided an opportunity to go to Hollywood and compete in the National Miss Black America pageant, to travel, make appearances, dance and speak at engagements. These things and more have helped me to mature and realize two important things: One is to speak so that I am able to communicate with others, and second, to be able to get along with people from all walks of life.

In 1977, I danced to win a pageant title and now I dance for my Lord and share my testimony. I would like to thank everyone again for giving this small-town girl a wonderful opportunity.

—Angela Watson Price

Aggie Artis Stanfield reigned as the national batting champion in 1974. He was a two-sport athlete, playing both football and baseball for the Aggies. He is from Burlington, North Carolina.

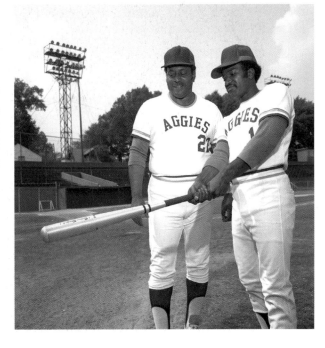

Pictured is the first contingent of the New Paul Robeson Theater at North Carolina A&T State University. Richard B. Harrison Players are presented as winners of acting and production honors during the 1973 season. Dr. John Marshall Killimanjaro (pictured on right) founded the theater in 1970. He served as executive director of the theater and the Richard B. Harrison Players from 1970 until 1981. He produced more than eighty major plays and musicals.

—John Marshall Killimanjaro

Miss Lee was a godsend to the students of Greensboro. I met her in 1978 as I was looking for employment as a teenager. Miss Lee hired me to be a tutor for the NAACP Tutorial Program. Miss Lee was a graduate of Bennett College. She had taught in the New York City Public School System. She retired and returned to Greensboro and joined the board of the Greensboro Branch NAACP. She convinced the board to head up the effort of educating our youth. The program was twofold. She hired teenagers from low income families to go to the public housing community and tutor elementary school students that were having difficulty in class. Miss Lee spent her own money to pay the salaries of the tutors. The job provided me with the training and character building skills that I needed to be successful in life.

Miss Lee taught us Black History. It was through her training sessions that I was able to gain an appreciation for

Mae Cynthia Lee.

the struggle of African Americans. Miss Lee not only touched my life but that of many African American students. She communicated with the parents, students and the schools. She knew the importance of education and she wanted to continue the cycle of learning. She encouraged us to be lifelong learners with goals for the future. She thought of us as her children and we thought of her as our mother. She was a great role model and mentor.

—Tijuana B. Hayes

Groundbreaking—Aggie Stadium

It was during the period 1979–1980 that considerable discussion was held by the Athletic Board in Control concerning the building of a football stadium. It was through the efforts of this committee that the stadium was completed in midsummer 1981 and dedicated "Aggie Stadium" on November 28, 1981. Mr. Edward Jenkins, AIA (an Aggie) was the architect.

—Dr. A.V. Blount

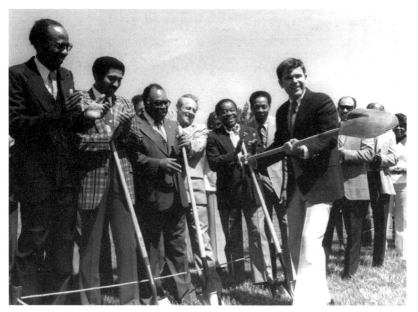

Mayor Jim Melvin breaks ground.

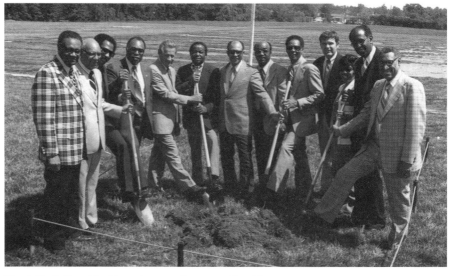

The Athletic Board in Control supporting groundbreaking.

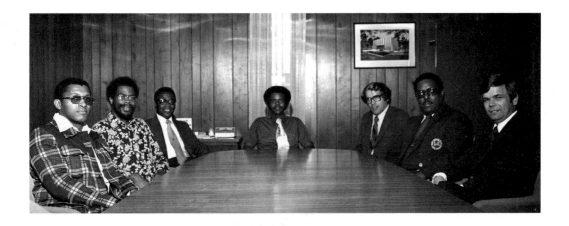

Parkway Services, Inc. was founded in 1973 by Edward Evans during his sophomore year at A&T State University where he was majoring in business administration. During the summer of 1973, Ed Evans and a few of his friends started a small business doing yardwork and housecleaning for Greensboro residents. A turning point in the company's growth came in 1975 when Parkway Services won the contract to clean the 19,000-seat Greensboro Coliseum. In 1982, Parkway Services became the first black-owned firm to win a contract with the Greensboro-High Point Airport Authority. Parkway has performed contracts in Florida, Alabama, Virginia, Ohio and Georgia, including services for the 1966 Summer Olympic Games in Atlanta.

—Edward Evans

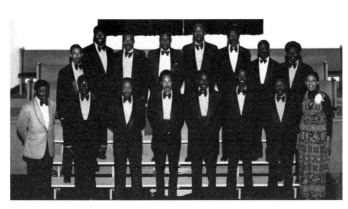

Greensboro Men's Glee Club.

I clearly remember as a ten-year-old child attending the first public concert rendered by the Greensboro Men's Glee Club under the direction of Mrs. Eloise Logan Penn. This performance occurred in the spring of 1936 at the Trinity Zion Church. From that time on, annual concerts were performed. Mrs. Penn unselfishly rendered three decades of invaluable service to this community project. These men possessed some of the finest male voices in the community, and the membership represented men from all walks of life. I was fortunate to be the piano accompanist for the chorale for five years under Mrs. Penn's direction, and after her retirement, I was honored to serve as the director during the last decade of its existence. During this span of years, all monies raised from concerts and public appearances were used to provide scholarship for worthy and deserving students.

—Carl O. Foster Jr.

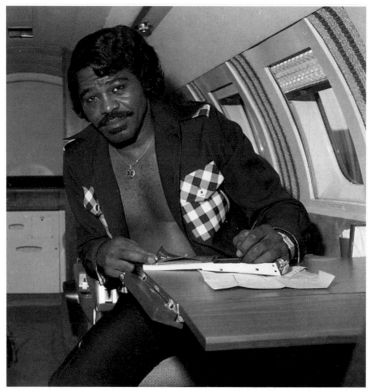

I received a call to meet James Brown at the Greensboro-High Point Airport as he flew into Greensboro. He had purchased a new jet and flew to Greensboro so that I could personally photograph him. It was a rewarding experience...but I never got paid.
—Otis Hairston

"The Godfather of Soul."

The Golden Gate Lounge began as a lifelong dream to own and operate my own business. I had retired from golf because I could not make the money I needed and wanted as a professional black golfer. The club was begun in the early '70s and was one of the premiere attractions for people of color in Greensboro. It was unique here because it was a private club and a key card was needed to enter. The atmosphere was warm and inviting—along with being private—and had an air of exclusivity. I later changed the name to the Street Scene Club.
—Murphy Street

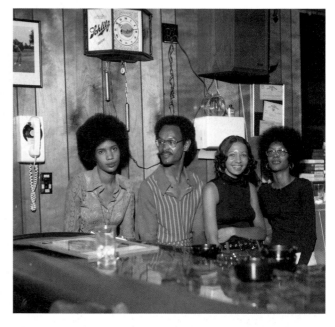

The Golden Gate Lounge.

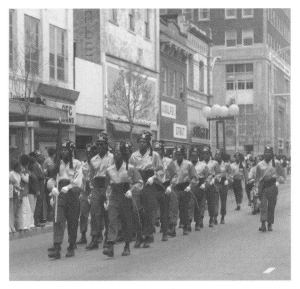

Khalif Temple #144 of Greensboro hosted the North Carolina Shrine Temples throughout the State of North Carolina for its Annual Gala Day. Events were held through the weekend, including a parade through downtown Greensboro. Approximately two thousand nobles participated. Noble Clarence Davis was potentate.

—Willie Gibson

1973 Gala Day.

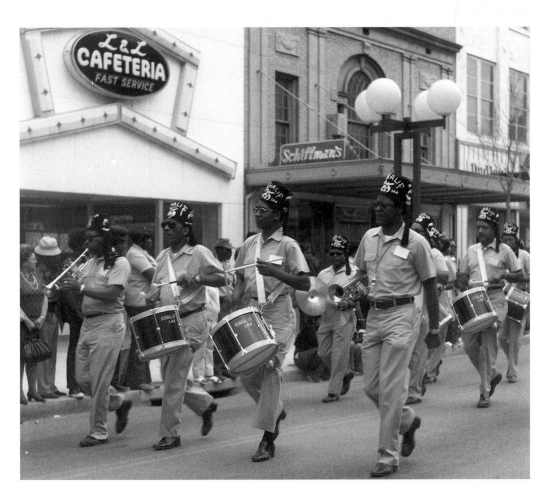

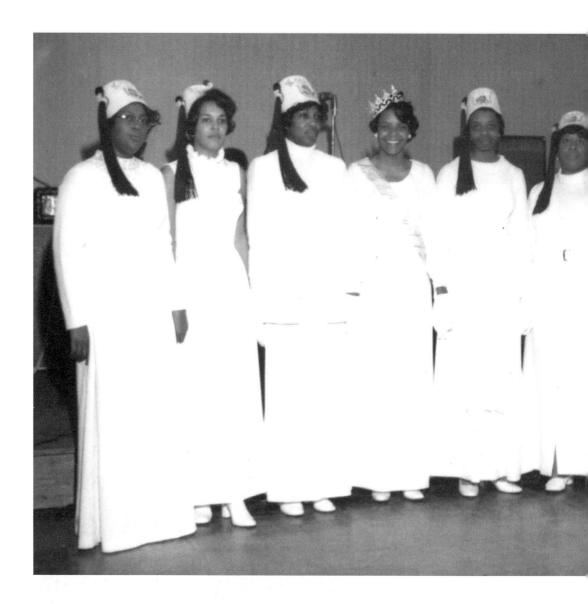

Girta Vines became a member of Khalif Court #90 in April 1973 and in December of the same year she was crowned "Queen of the Court" for the ensuing year. The late Jacqueline Wright was the illustrious commandress. The Queens Ball was held at the Golden Eagle in downtown Greensboro.

The court was established in 1946 and has grown in membership and activities. The court is very active in the community, donating to local charities, giving annual scholarships and has established a joint recreational bowling unit with Khalif Court #144. Pictured are the contestants in the contest.

—Girta Vines

Khalif Court #90.

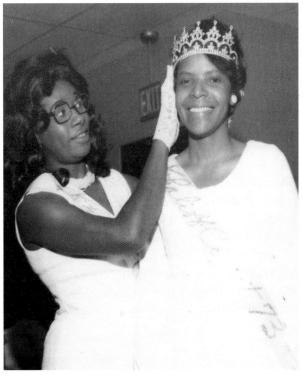

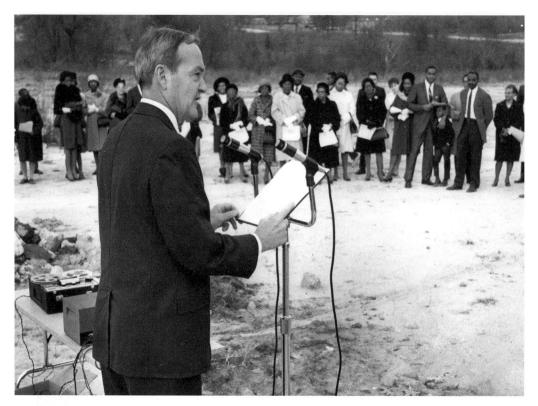

The Shiloh Housing Story.

For sixty or more years, Shiloh church building was located in the center of a community surrounded by substandard housing. It was common for rats to come up through holes in the floors and for rooms to be flooded with water during rainy seasons. The landlords showed no interest in improving or correcting these disgraceful dwellings from which they collected rent. The city government failed to pursue any course of action that would demand that landlords bring these shotgun houses up to a level of decency.

Under a new HUD program, the church voted to form a nonprofit corporation to apply for sponsorship of housing for low income families. It was voted to name the project, if approved, the J.T. Hairston Apartments in honor of the late pastor who served the church for fifty-three years. Approval was granted by the Federal Housing Administration for 108 units. Groundbreaking was held with the late Congressman L. Richardson Preyer speaking. This was the very first church-sponsored housing in the State of North Carolina.

Two of the first residents to move into the units were two elderly members of Shiloh, the late Bertha Pearson and Ida Lou Johnson. Mrs. Johnson said, "It's a heap nicer than the old one." She was especially grateful that it was also less expensive. Mrs. Johnson paid only thirty-six dollars per month, including heat, lights and water. Said Mrs. Pearson: "Because where I lived for more than fifty years, I had to use wood and coal." She further stated that "Shiloh is preaching the gospel and living the life."

—Otis L. Hairston Sr.

The Stork's Nest.

The Stork's Nest was launched in Atlanta, Georgia, in 1971 as one of many educational and service projects to provide better infant care. The program was sponsored by the March of Dimes.

On March 1, 1975, Beta Nu Zeta opened a Stork's Nest in Greensboro with a ribbon-cutting by then Mayor Jim Melvin.

Customers of the Stork's Nest were referred by Guilford Health and Welfare Clinic. Greensboro's project was the first in the eastern region of Zeta Phi Beta Sorority, Inc. The Stork's Nest secured nurses to teach mothers how to take care of their babies. It had a thrift shop to benefit the needs of the project.

Award-winning recording artist N.C. A&T University Fellowship Gospel Choir was organized in 1969 under the direction of Dr. Albert Smith and the late Rev. Cleo McCoy, Chaplain of N.C. A&T State University, and residents Yvonne (Haygood) Smith and the late Frances Parker.

—Don and Yvonne Smith

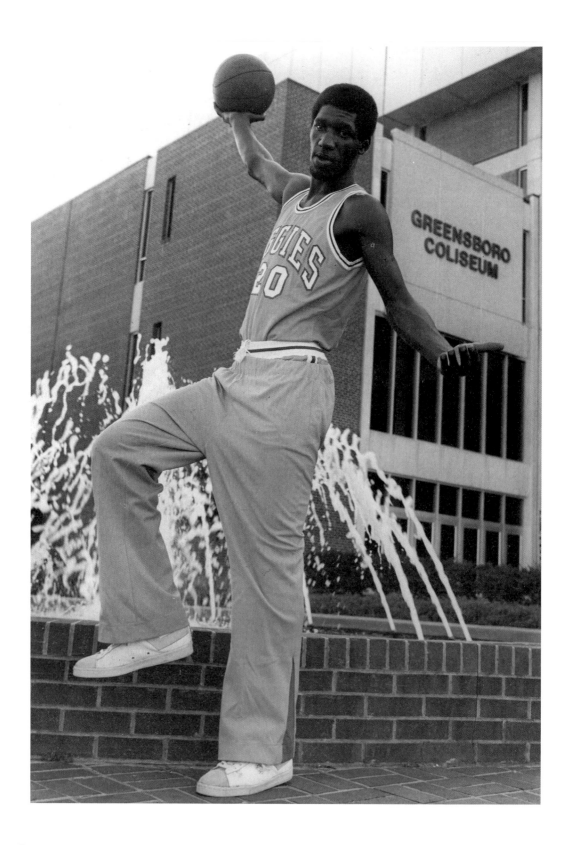

Sparrow was a prolific scorer who played point guard and shooting guard. He could go to the basket or pull up and take the jumper. His passing was sensational. If you were not looking, he would hit you in your face. You could always expect a double/double from him each and every night—sometimes a triple.

<div align="right">

—Al Carter

</div>

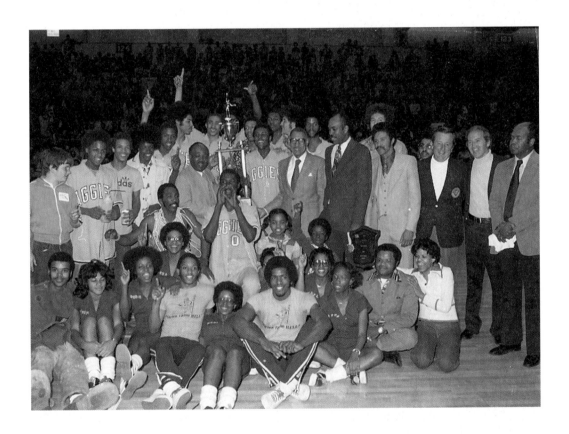

Left: James "Bird" Sparrow.
Above: James Sparrow led the Aggies to the 1976 MEAC championship title.

Rev. Dr. Cardes Henry Brown Jr.

The journey that led Rev. Brown to Greensboro and later to New Light is an interesting one. He was called into the proclamational ministry during his sophomore year at A&T College. Shortly thereafter, he was asked to pastor the Mount Gilbert Baptist Church in Scotland Neck, North Carolina. His journey brought him to Reidsville, North Carolina, in 1970 to pastor at Elm Grove Baptist Church where he served for five years before coming to New Light. It is ironic that Rev. G. Griffin pastored both at Elm Grove and New Light for more than twenty years simultaneously. Comparably, Rev. Brown gave consideration to pastoring both churches before coming to New Light full time in 1975. In February 2007 Rev. Brown celebrated thirty-two years of pastoral service to New Light Missionary Baptist Church. In addition, Rev. Brown is president of the Greensboro Branch NAACP and is an outstanding spokesman in encouraging all people to "do the right thing."

—Millicent Lee

Uhuru Bookstore 1973 Anniversary.

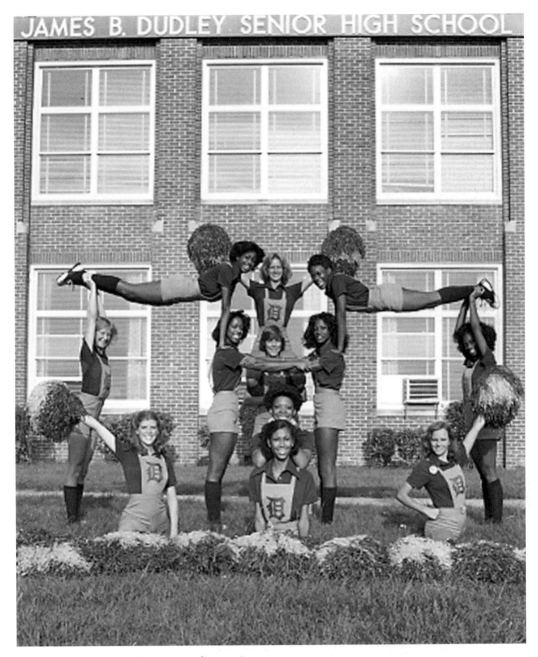

Dudley High School: The beginning of integration.

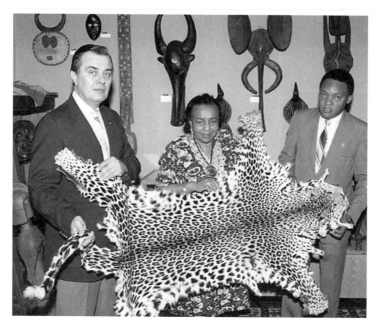

Mattye Reed began a collection of African artifacts that has grown to be one of the largest collections in the country. The collection is now housed in the Mattye Reed Gallery in the newly renovated Dudley Building.

The Mattye Reed collection continues to grow as gifts such as this beautiful leopard skin is added to the collection, donated by B&C of High Point, North Carolina. As you can see, Mrs. Reed is pleased to receive this wonderful gift, which will be one more African artifact to share with the community.

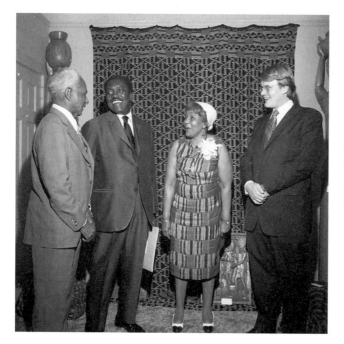

Mrs. Reed and guests welcome the ambassador from Ghana at the opening celebration of Afro House on the campus of North Carolina A&T State University.
—LeAnder Canady

The 1980s

Space Shuttle Astronaut Dr. Ronald McNair, with his dear mother, a schoolteacher and lifelong source of inspiration for him.

The story of Ron McNair is the story of a stellar achievement—from picking tobacco in South Carolina to getting an undergraduate degree in physics from N.C. A&T State University, to getting a PhD in laser physics from MIT and finally becoming the first civilian African American space shuttle astronaut. Unfortunately, his life was cut short in 1986 when he and six other astronauts died aboard the ill-fated space shuttle Challenger. Ron never forgot A&T and often returned to inspire students. One of his favorite phrases, "You're good enough," was directed at students who were not sure they could pursue their own big dreams. He was the inspiration behind the N.C. A&T Student Space Shuttle Program, a student project that resulted in the flight of two science experiments aboard the space shuttle Endeavor.

—Dr. Stuart T. Ahrens

Walter F. Carlson.

For forty-seven years, Walter F. Carlson Jr. touched the lives of students at A&T College and later N.C. A&T State University. For years he was the only A&T band director the Greensboro community knew.

During Mr. Carlson's era, the college marching band earned a reputation for precision in performance...from the high-stepping quickstep entrance onto the field to the richness and depth of tone quality. These achievements were attributable to Mr. Carlson's insistence on perfection gained only through perfection in practice. One of his favorite expressions was "repetition makes reputation."

Mr. Williams came to A&T in 1960 as assistant band director. He later served as director of the Jazz Band and Percussion Ensemble. He assisted in organizing the Alumni Band and the ROTC Band. He served as one of the directors of the marching band until his retirement.

J.J. Williams.

Mr. Johnny Hodge served one year at A&T in 1973. He left to pursue his PhD and returned in 1977. From that point on he was known as "Doc." He became full-time director of bands and professor of music in 1980. The Hodge years began through the guidance of "Doc" and the marching band became nationally known as "The Blue and Gold Marching Machine."

Dr. Hodge has touched many lives through his tutelage, his wisdom and his words of wisdom. He retired in 2002.

Above: Johnny "Doc" Hodge.

Below: The 1984 Aggie Marching Machine.

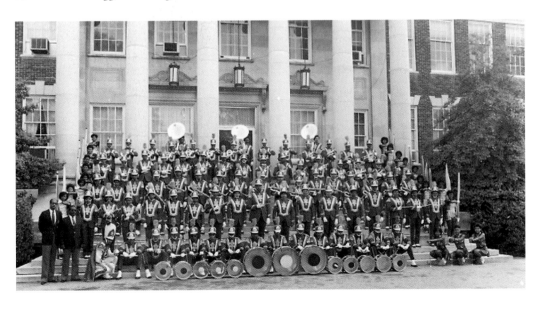

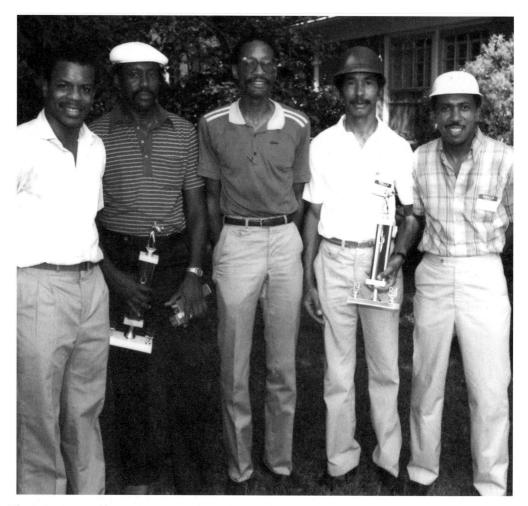

The R.L. Wynn Golf Tournament.

The R.L. Wynn Invitational Golf Tournament was organized in 1982, after the passing of Mr. Robert L. Wynn, affectionately referred to as Uncle Bob.

This tournament became the focal point of a great weekend each year in early August in memory and honor of Mr. and Mrs. Wynn.

Proceeds from the tournament went into the Robert L. and Margaret H. Wynn Memorial Scholarship Fund. Beginning in 1983, a scholarship was given annually to a deserving student from Guilford County. Mr. and Mrs. Wynn believed strongly in education as Mrs. Wynn was an elementary schoolteacher and Mr. Wynn became the first African American dairy extension specialist in the United States.

—Ralph K. Shelton

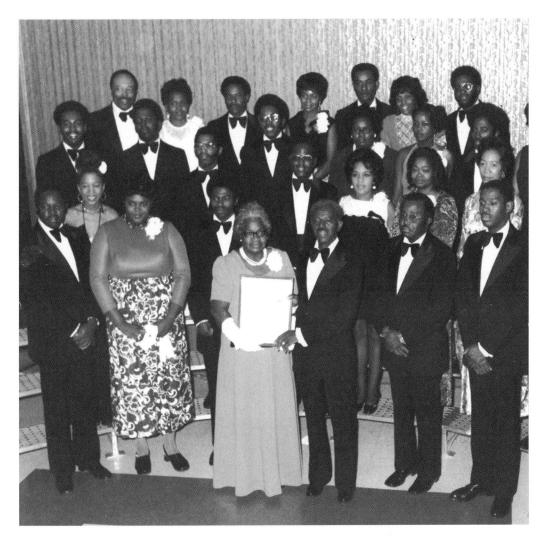

N.C. A&T State University honored the Parker family for its outstanding commitment to education. Thirteen of the children graduated from institutions of higher learning. Eleven of them graduated from A&T. Fourth from the left are parents Mrs. Vallie and Mr. William Parker Sr.
—Clifton Parker

The Sisters of Unity were organized in March 1973. They wanted to make a difference by helping persons in the community in distress. They helped many families who had been burned out of their homes, persons with prolonged illnesses, nursing homes at Christmas and anyone in the community who needed a helping hand.

They held gala affairs, such as a Black & White Ball, fashion shows, masquerade balls and sponsored trips to college and professional football games.

—Thurstena Stephens

Don Forney worked hard to make a positive difference in the lives of many people in Guilford County and surrounding areas. His employment as a social worker, probation officer, director of two federal programs (OEO and Model Cities) in High Point, director of community affairs at WGHP television station and

an entrepreneur in Greensboro represent channels that enabled him to make a significant impact on the community. He was the owner of Yenrof's (Forney spelled backward) in Greensboro, which was an entertainment spot frequented by many local professionals. Forney is pictured on the left.

—Ruth Forney

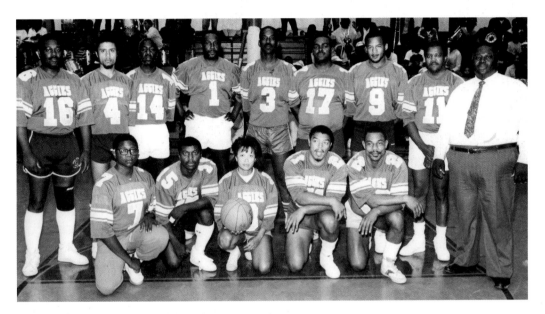

Aggie faculty and staff basketball.

This picture brings back memories of my early days on the faculty at N.C. A&T State University. This was in the 1980s when Mo Forte was the head football coach at A&T. I know this because George Ragsdale, who is also pictured, was Mo's assistant coach. During that time I was working in the school of business as an accounting lecturer. Also in the photo are my dear friend and homeboy Lonnie Sharpe, the coach of the team, the late Leon Warren and James "Black" White. The Faculty and Staff Basketball Game was an annual ritual where youthful, and sometimes not so youthful, faculty and staff got to show off their fading basketball talents. The opposing team would have consisted of faculty and staff members. Dr. Harold Martin, the former dean of the School of Engineering, would have been on the opposing team. You could always expect a competitive, yet fun game because of talented and athletic individuals like Lonnie Sharpe, Ragsdale and Harold Martin.

—Dr. Jerry Thorne

The Greensboro Young Men's Club.

The Greensboro Young Men's Club is an organization that was founded in the early 1970s as a vehicle for young men to engage in civic and social activities. The charter members were Tom Scott, Marquis Street, Tyrone Johnson, Claude Merritt, Richard Bowling, William B. Geter, Otis Hairston, James Howerton and Preston Fleming. The organization provided a social outlet and a medium whereby community issues could be discussed and acted upon. During the 1970s and 1980s, the Greensboro Young Men's Club gave assistance to individuals and community groups in the form of financial contributions. On an annual basis the Greensboro Young Men's Club would honor a youth, a male and a female, for his/her outstanding contributions to the community.

Pictured at the Annual Awards Ceremony are, from left to right: Fred Whitfield Jr., Rev. Prince Graves, Mae Cynthia Lee and Howerton.

—James Howerton

"Carl's Famous Foods" was known throughout the Greensboro community. The owner, Carl Manuel Sr., dedicated his life to people and the food services industry. Among his most noteworthy catering events were: (1) serving the inaugural reception for Governor James B. Hunt Jr. at the governor's mansion in Raleigh, (2) the GGO Golf Championship banquet at the Greensboro Coliseum and (3) summer feeding programs at N.C. A&T State University. He operated several restaurants in southeast Greensboro.

—Carl Manuel Jr.

Carl's Famous Foods.

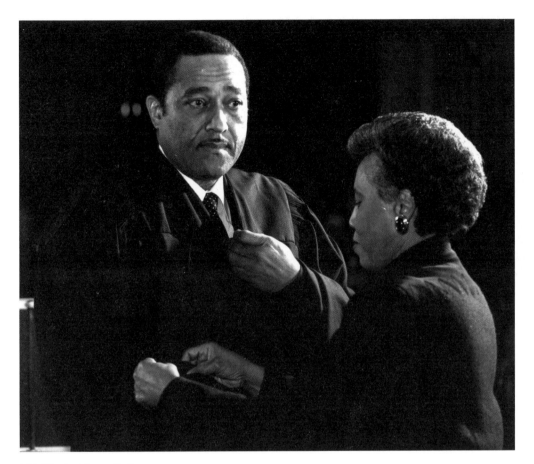

Chief Justice Henry E. Frye.

The photo is historic in several respects: it shows me donning the judicial robe, assisted by my wife Shirley, after taking the oath of office in the Guilford County Courthouse on January 3, 1985, following my election to an eight-year term on the Supreme Court of North Carolina. I was appointed to the court in January 1983 by Governor James Hunt Jr. and took office as associate justice on February 3, 1983, in the Supreme Court building in Raleigh. In 1984, my election to an eight-year term was contested both in the democratic primary in May and the general election in November. I ran unopposed, however, in the primary and general elections in 1992. In 1999, Governor Hunt appointed me as chief justice to serve until the next general election in November 2000. Being the first African American appointed to the Supreme Court, the first to be elected to the court and the only African American to serve as justice is historically significant.

—Henry E. Frye

Growing up, I had a good support system from my family and friends. My family was a very sports-oriented family. I was a three-letter sportsman at Dudley in basketball, track and field and football. However, football was my passion.

Colleges such as Clemson, Virginia Tech, William Salem State and N.C. A&T State University made scholarship offers. I decided to choose A&T to remain close to home. While at A&T I worked very hard and showed commitment by listening and learning from my coaches. With my dedication, I was able to start as a freshman defensive back. I learned how to apply the skills I learned to do my job covering the field as a defensive back. I actually had the opportunity to cover Jerry Rice in the Freedom Bowl, and of course I made it very difficult for him. I was voted MEAC all-conference my junior and senior year.

This picture of me and Jerry Rice is from a very memorable and rewarding time in my life. We were in Atlanta playing in the Freedom Bowl, and we were both candidates for the National Black College Player of the Year Award. Even though I did not win, I realized all the hard work and commitment of always giving 100 percent had paid off. I was grateful to have achieved such an accomplishment and recognition. This was indeed a good year for me…not long afterward, in 1985, I was drafted by the Minnesota Vikings and later traded to the Oakland Raiders.

—*Tim Williams*

"Tim and Jerry."

My baseball interest began attending Negro league games with my dad in Harrisburg, Pennsylvania. I graduated from Dudley High School in 1954, earning a baseball scholarship to A&T College. After two years in the army, I played Negro League Baseball then signed with the New York Mets organization from 1960–65. In 1978 I became the first full-time commissioner of the Mid-Eastern Athletic Conference, serving until 1996. I became the first African American on the NCAA Division One Men's Basketball Committee in 1987. I served as commissioner of the EICA Conference from 1996–2006.

—Ken Free

"Mr. Commissioner."

Gate City Beauticians.

The Gate City Beauticians Association was founded in 1939 in the home of Mrs. Lekia Morrison for the purpose of promoting goodwill, understanding and appreciation for persons engaged in the field of cosmetology. For many years the Gate City chapter had the largest membership in the State of North Carolina. The chapter is still active, under the leadership of Robert Johnson, and continues to make progress.

—Carrie Hardy

"The People's Man."

Jimmie I. Barber was elected to the Greensboro City Council and served more than eleven and a half years. While on the council, he worked for greater representation of minorities on boards and commissions. By the end of his tenure, one hundred and two minorities had been placed on city boards and commissions.

Many citizens of the Greensboro community petitioned the City of Greensboro to rename Southeast Park the Jimmie I. Barber Park, which was dedicated in his honor June 4, 1989. He was indeed the "People's Man."

—Kathryn Bennett Barber, "Sugarfoot"

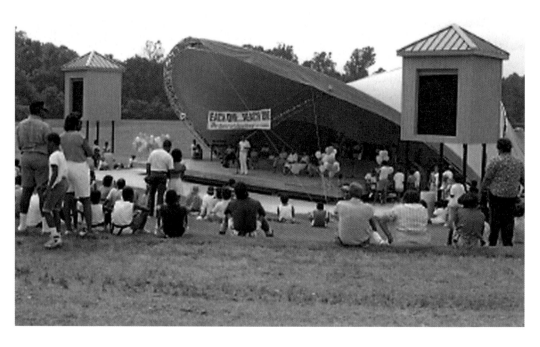

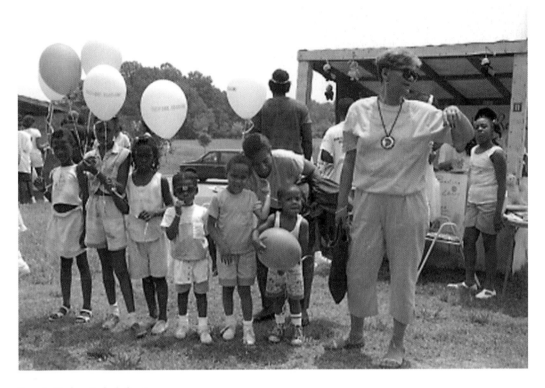

Jimmie Barber Park dedication.

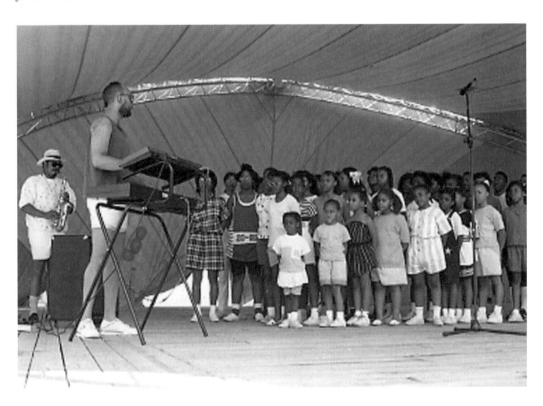

Left: "Coach Corbett."

Below: Aggies NCAA appearance against Kansas under Corbett.

Coach Don Corbett's basketball coaching career at N.C. A&T spans from 1979–1993, compiling a record of 249 wins and 133 losses. He ranks second on the all-time victories list behind Coach Cal Irvin.

Coach Corbett had eight consecutive MEAC conference championships and seven consecutive NCAA tournament appearances. He was named MEAC coach of the year six times and had a player win MEAC player of the year six times.

In January 2006 at Corbett Sports Center, the court was named in honor of Don Corbett and Cal Irvin. Coach Corbett has established himself as a true legend at A&T and in the MEAC.

—Dewey Turrentine

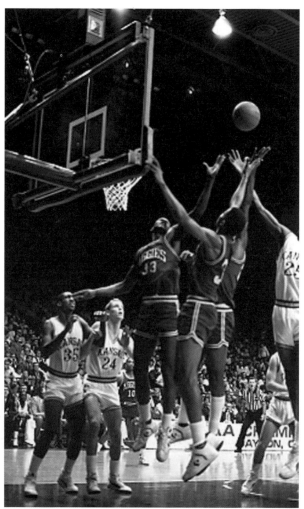

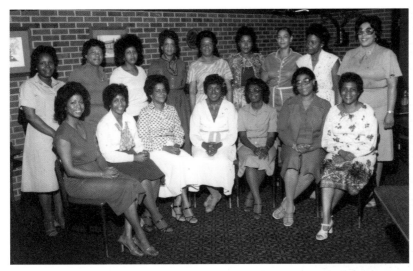

Eta Phi Beta Sorority.

Alpha Rho chapter of Eta Phi Beta Sorority, Inc. was established in 1973. The organization was founded in Detroit, Michigan, in 1942 by eleven businesswomen. Eta Phi Beta is an affiliate of the National Council of Negro Women.

On the local level, the sorority sponsors scholarships to deserving high school graduates and makes contributions to the United Negro College Fund, the Special Olympics, NAACP and ARC. Programs of interest include high school career day activities, scholarships to McIver School and Thanksgiving and Christmas projects

I served as mid-eastern regional director from 1999 until 2003. I am proud to be affiliated with an organization that is dedicated to leadership and its achievements in cultural and civic endeavors.

—Patricia M. Posey

The Progressive Community Club.

The Progressive Community Club was a neighborhood organization located in the Spaulding Heights community. It was organized in 1980 by Mrs. Sadie Brown. The club would meet on a monthly basis in the homes of the members until about 1995. We had approximately twenty active members. Our mission was to know our neighbors and give support to our community. The neighborhood consisted of our homeowners, restaurants, clubs, a gas station and a fish market.

—Ora M. Morehead

"Guys and Dolls."

The Guys and Dolls, Inc. was organized on September 5, 1965, in Greensboro. Shortly thereafter, the organization was registered and chartered by the State of North Carolina. The founders were Mrs. Eula Vereen and Mrs. Roberta Judd. The purpose of the organization was to plan, organize and carry out fruitful and educational activities for children and parents of like interest.

—Maxine D. Davis

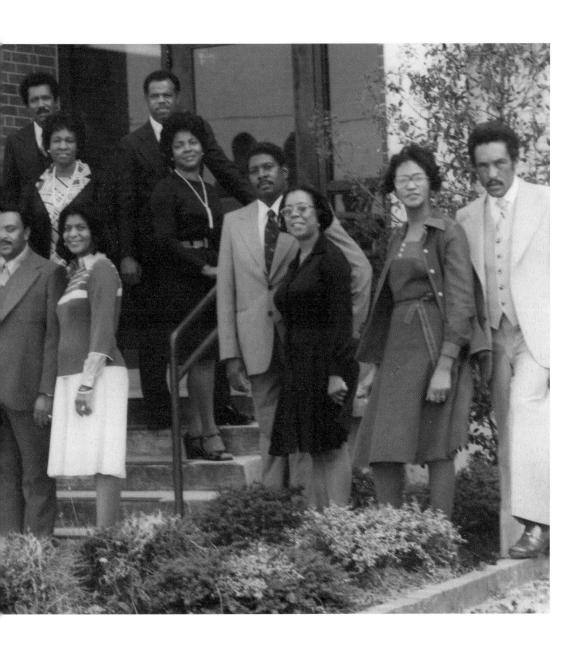

The Greensboro Coliseum celebrates its thirty-millionth patron.

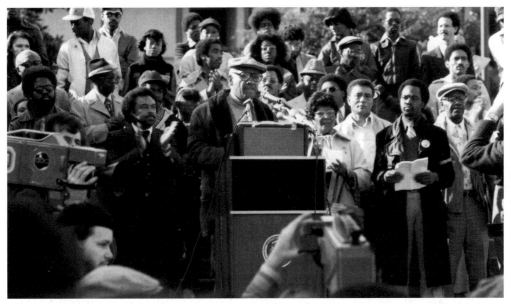

Voter registration rally.

Dr. George Simpkins speaks at a rally for voter registration and voting rights at N.C. A&T in the early 1980s. The rally was organized and led by Wayne Clapp (front row, second from right) who later received the NAACP Community Service Award for registering over two hundred new voters.

—Wayne Clapp

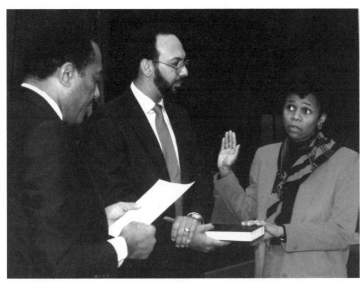

"Clerk of Court."

Justice Henry Frye administered the oath of office to me after I was elected clerk of Superior Court of Guilford County in 1986. I served until 1990. I was the first African American elected to this office.

I was admitted to the North Carolina Bar in 1974. I am now in the private practice of law.

—Barbara Gore Washington

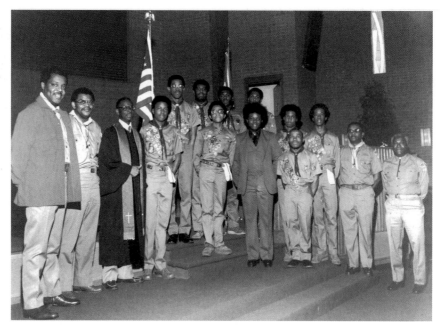

Shiloh Eagle Scouts.

The Shiloh Baptist Church Boy Scout Troop #443 was organized in 1925 under the leadership of Rev. J.T. Hairston, B.S. Austin, B.H. Boone and others. In 1970 the troop was reorganized under the leadership of Rev. Otis Hairston, U.J. Cozart, Melvin Henderson, Jack Dewar, W.I. Peterson, Ralph Chalmers and others.

The troop was recognized nationally in the 1980s for the large number of scouts that had attained the rank of Eagle Scout (41), Order of the Arrow members (17), Silver Beaver recipient awards (6) and scouts completing a course in troop leadership development (12). For two years the troop received the Presidential Award.

Ron Bailey and Don Massenburg are current scoutmasters.

—U.J. Cozart Sr.

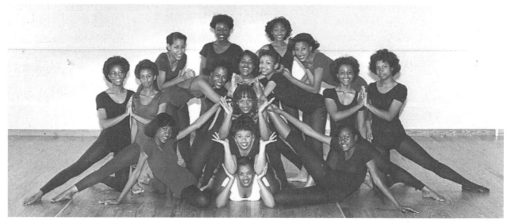

The 1981 Dudley High Dance Group: the tradition continues.

The February One Society·

The February One Society was the outgrowth of a twentieth anniversary sit-in anniversary program. It became the sponsor of annual sit-in related observances during the 1980s and early 1990s celebrating the "Greensboro Four." The February One movement supported the city's goal to achieve one community.

—Hal Sieber

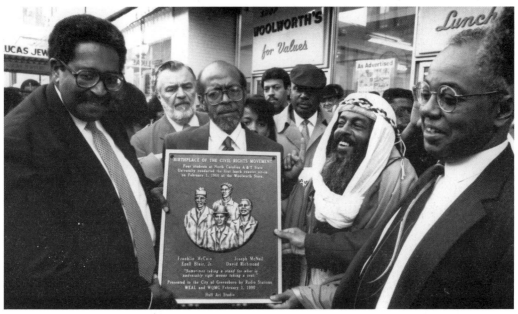

Memorable moments of the 1980s sit-in celebrations.

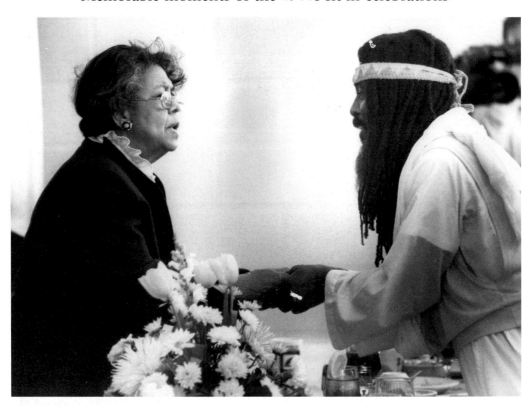

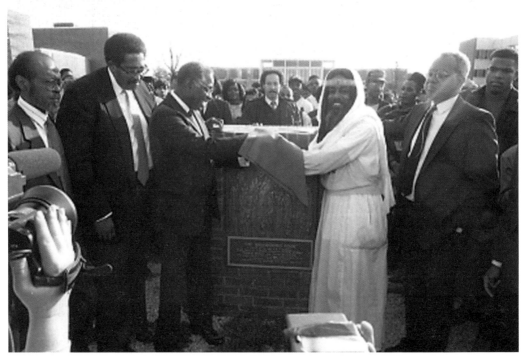

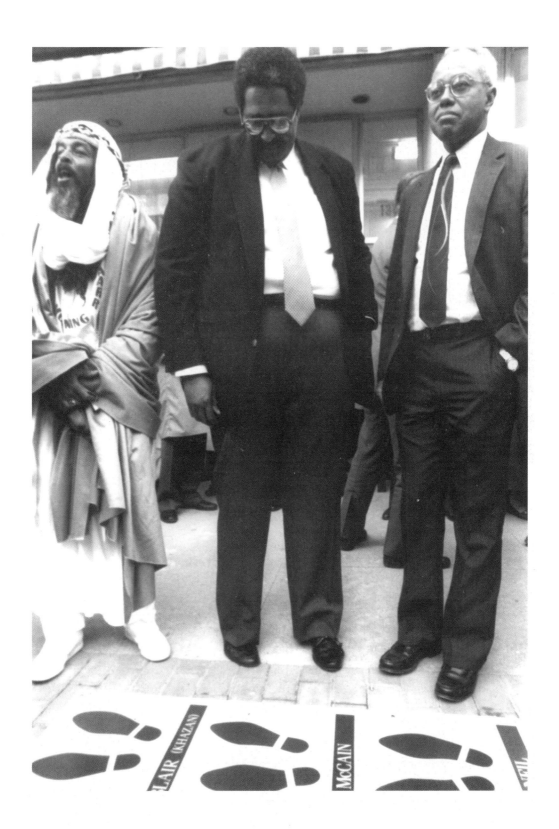

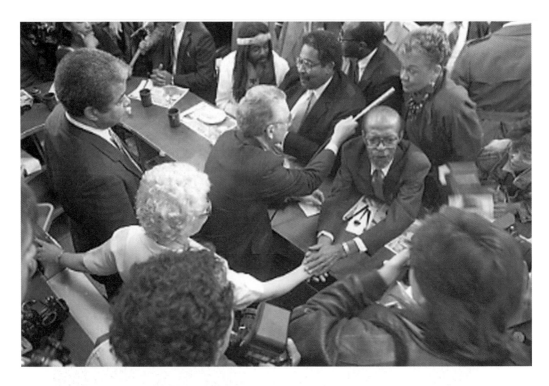

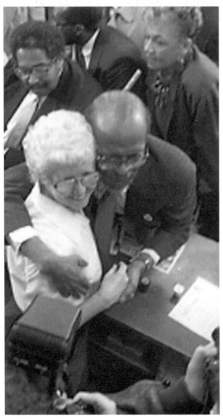

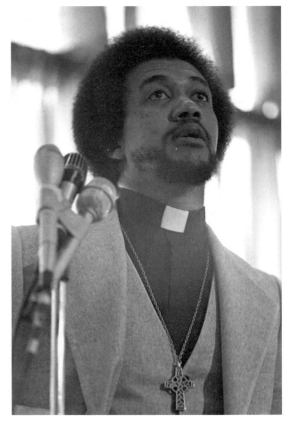

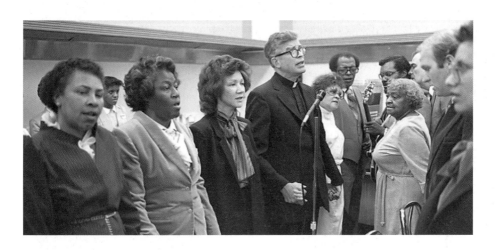

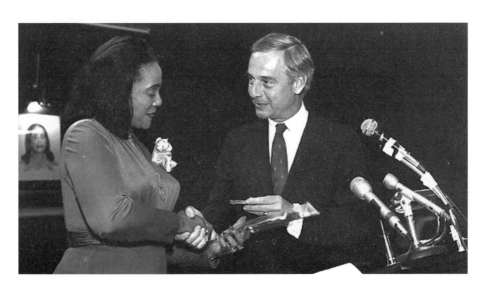

Alex Haley spends time on the campus of A&T State University. One month after his visit he died of a sudden heart attack.

Emma Morgan McAdoo, educator of children, families and communities, was born in Greensboro and married to the late Hilton McAdoo. She graduated from A&T College after having nine children. She served as president of the PTA at Washington Elementary, Lincoln Junior High and James B. Dudley High School. She often states and believes that "work is love made visible," which has been noted by her receiving the Urban Ministry Service Award and Outstanding Teacher of the Year Award, and

Emma McAdoo.

being selected as one of the African American Women of Distinction and Grassroots Hall of Fame "Women of the Village." She has served as director, president, chairperson, trustee and or member of over thirty boards, committees, councils and organizations.

—Bea McAdoo-Shaw

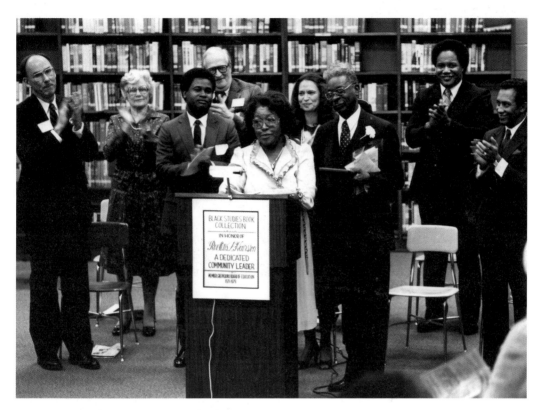

Black Studies Collection.

Mrs. Mary Battle, media director at **J.B. Dudley High School**, honored the Rev. Otis Hairston in the late 1980s with the beginning of a Black Studies Collection in the media center of the school. The collection was to bring awareness to the students of the school about the work of the many black authors and the legacy and history of African Americans.

Rev. Hairston was a community activist, civil rights leader in the sixties, member of the Greensboro School Board during the period of school integration and pastor.

—Monica Belle

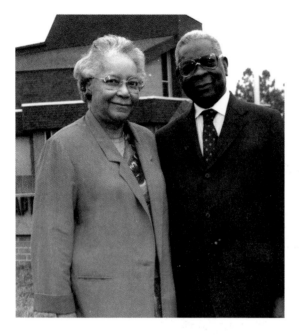

On a typical Saturday afternoon, I was relaxing, watching college football and awaiting a call from my parents who had traveled to their alma mater Shaw University for Founder's Day and Homecoming Weekend celebrations. After several successive pages from my answering service, I responded and was informed my parents had been in an accident on I-85 near Burlington and had been transported to a local Greensboro hospital.

Arriving at the hospital, I found my father sitting in the waiting room and my mother still being examined. The strength and faith of my father was so apparent in his words, "I'm OK." I checked on my mother and she showed no signs of injury except for a couple of minor scratches.

My feeling of relief was just, "Thank you Lord, Thank you Lord."

After a brief wait, the hospital released my heroes and I transported them home as they shared the story of their accident. They had collided with an eighteen-wheeler, and the car had flipped over several times before landing on its roof. They could hear people approaching the car saying, "I know they are dead."

Upon arriving at their home, I was sent to the towing company to pick up their personal items. As I stood in disbelief viewing the incredible damage done to their car, the severity of the accident finally struck me. With tears rolling down my face, I realized how God had wrapped his loving arms around my parents and brought them through this tragic accident. His message to them was, "I'm not through with you yet." It was God's Grace and Mercy! Less than twenty-four hours later my father was in the pulpit of Shiloh Baptist Church proclaiming "the love and goodness of God."

To God Be Thy Glory.
—Otis Hairston Jr.

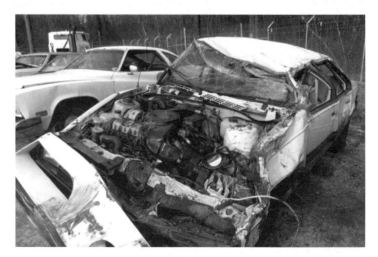

Saturday, November 26, 1988.

72

The 1990s

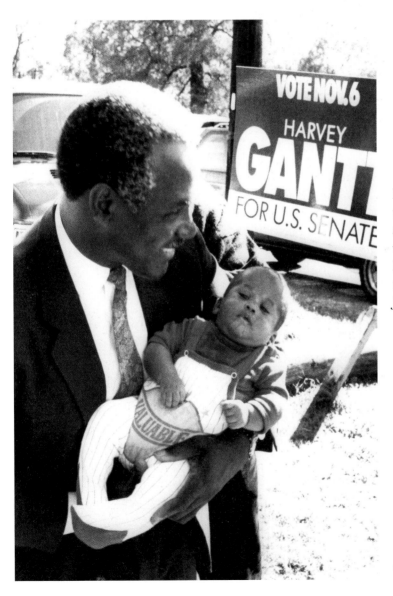

Harvey Gantt takes time out to recognize another potential leader while in Greensboro on his campaign trail for the U.S. Senate against Jesse Helms.

"Gantt Campaigns."

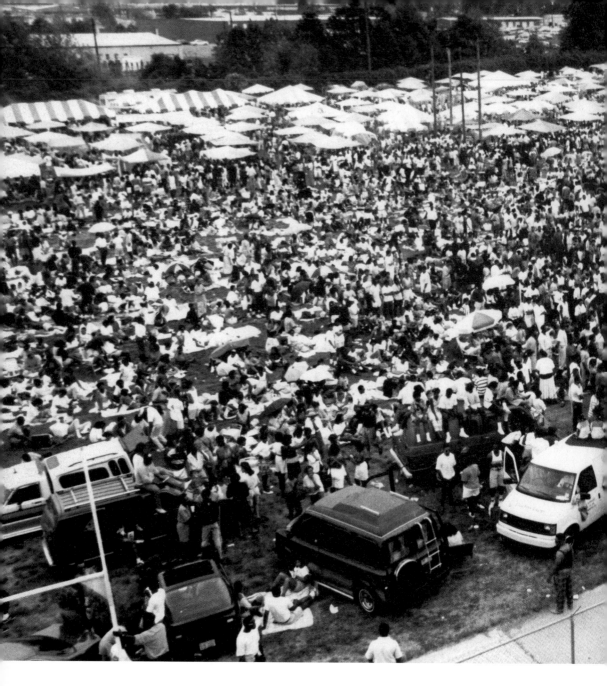

In the early '80s, a phenomenon called Aggie Fest was created at N.C. A&T State University. This activity occurred on the football practice field next to Aggie Stadium in the spring of each year. This outside event usually had five or six performing groups, and people were allowed to set up tents and they also could grill food and have fun group activities. In the beginning around four thousand people attended, but by 1989–90, this event attracted around fifteen thousand people from all over the country. The end result, however, was traffic jams both in the city and on the highway running parallel to the

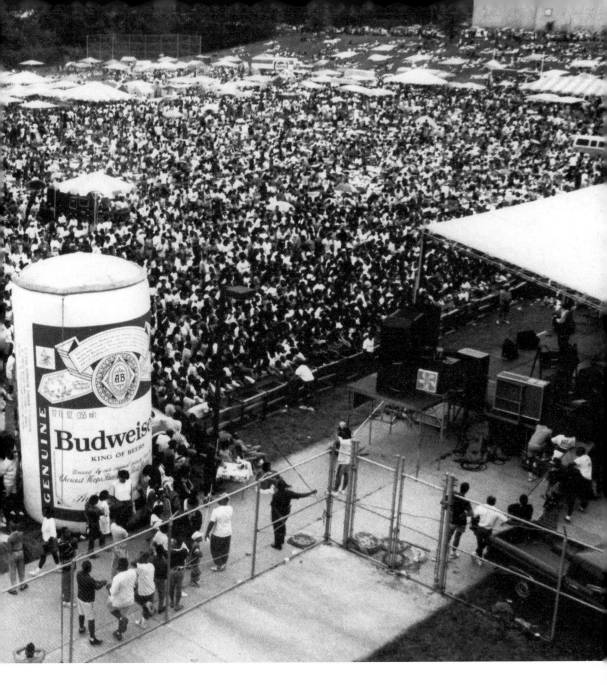

university. Additionally, individual property damage soared, with over one hundred arrests made by Greensboro and A&T police for drugs and violence, causing Chancellor Edward B. Fort to evaluate the continuance of this university activity. It was determined that the negative impact of this event would affect the positive image of the university. Therefore, Chancellor Fort, in April 1990, mandated that this event would not occur anymore at the university.

—Dr. Sullivan Welborn

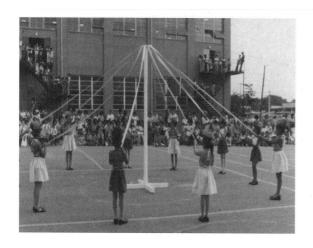 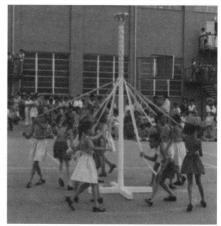

Year after year Hayes-Taylor YMCA has kept the promise to its founders and benefactors by putting Christian principles into practice through programs that build a healthy body, a sound mind and a liberated spirit for all.

Established traditions, such as the annual youth May Day celebration that features the wrapping of the May pole, are a part of the YMCA rich experience. The ceremony removing the 1939 cornerstone from the original building and placing it in the 1997, $5.5 million, expanded and renovated Y building is another important benchmark in the history of Hayes-Taylor Y. Pictured below are: Dr. S.C. Smith (left), John Marable (center) and Clarence Spencer (right).

Throughout the nation, and perhaps the world, you will find someone who in one way or another has been touched by the Hayes-Taylor Y.

—Thomas J. Scott Sr.

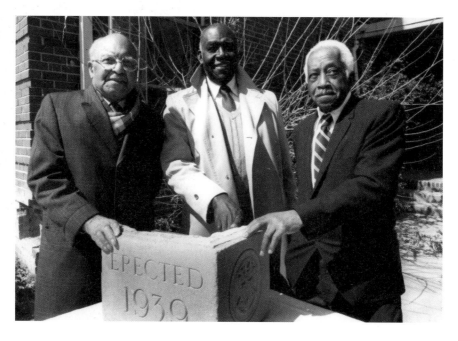

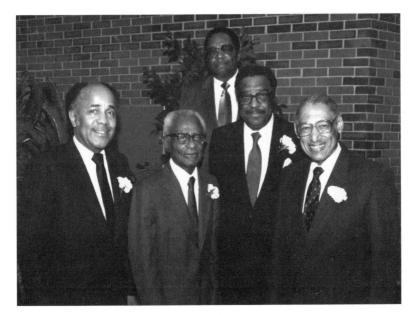

Pictured. left to right. are: Dr. Edward B. Fort, Dr. Warmouth T. Gibbs, Dr. Samuel Proctor, Dr. Lewis C. Dowdy and Dr. Cleon Thompson (rear).

The five living chancellors join in celebrating the centennial of N.C. A&T State University; a historically significant observance in 1991. The year-long celebration pinpointed the significance of this black university's internationally recognized world-class status. From astronauts to presidential candidates, it continues producing some of the best.

—Dr. Edward B. Fort

Attorney Romallus Murphy is legal redress chairperson for the local NAACP and served as legal counsel for the state of North Carolina NAACP until 2006. In October 2006 he was honored with the establishment of an Annual Continuing Legal Education Program (CLE) bearing his name where lawyers will continue their pursuit of legal education. He received in the same year the Trail Blazer Award from the National Civil Rights Museum.

The meaningful accomplishments of Romallus Murphy have affected the lives of many people across the state of North Carolina and across the nation.

—Gale Murphy

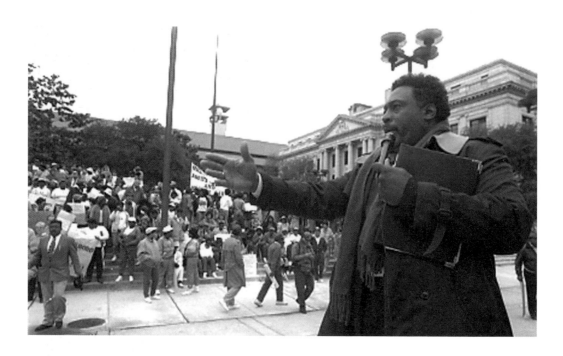

As president of the Pulpit Forum at the time of March 2007, these photographs represent the collective concerns of ministers and other grass roots organizations in response to the devastating budget cuts from indigent healthcare. The prevailing thoughts were that masses of poor people with little or no resources would have no access to affordable healthcare. Many attempts were made to compel the powers that be to consider that "we are only at our best when we are helping others to become their best." We were moved not so much by the economic trends and indicators that were somewhat erratic, but rather by the spirit of Christ whose concern was always for the least of the little ones.
—Rev. William Wright

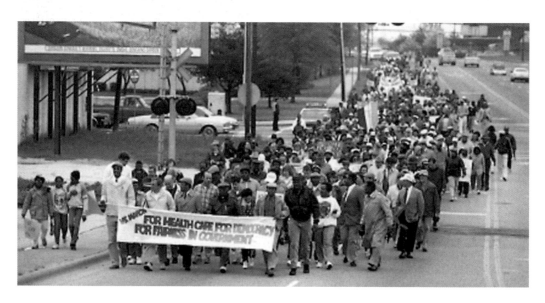

This page and opposite:
Protesting county funding cuts.

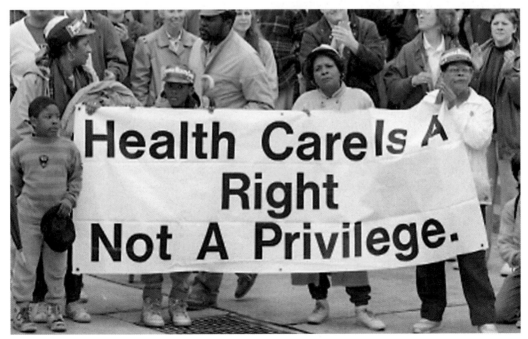

Challenge Greensboro was the brainchild of Ken Alston, the director of Greensboro Education and Development Council (GEDC). The purpose of the program was to prepare and inspire minorities for leadership roles in the Greensboro community via joining public boards or seeking public office. Local employers nominated outstanding employees who had an interest in public service for the nine-month program.

The format of the program was to expose the participants to the inner workings of both city and county governments. The community's long-range planning objectives were shared, as well as an overview of public and private community services. Resource personnel included local leaders and leadership trainers from the Center for Creative Leadership. The program was very engaging and successful. Pictured are Ken Alston and the 1992 Challenge Greensboro class.

—Paula M. Jeffries

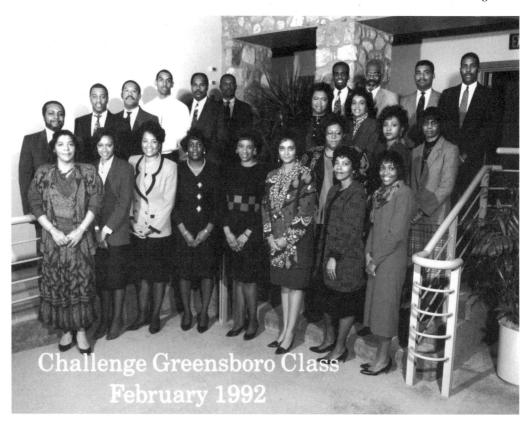

Challenge Greensboro Class
February 1992

Commission on the Status of Women.

The Greensboro Commission on the Status of Women was established in 1973 as an advisory group to the Greensboro City Council. The commission works with local, state and national organizations on issues that may impact the economic, social and physical well-being of women. Fifteen volunteer commissioners, who are appointed by the City Council to serve three-year terms, oversee the commission's efforts. While the commission does not offer direct services, it identifies the needs of women and barriers to women's advancement. The work of the commission is accomplished through various committees. Committees may conduct studies, suggest areas of concern, assist in the investigation of complaints, identify existing agencies that can address the recognized needs and support new initiatives that seek to improve the quality of life for women in Greensboro.

—Jean Ellis Hudgens

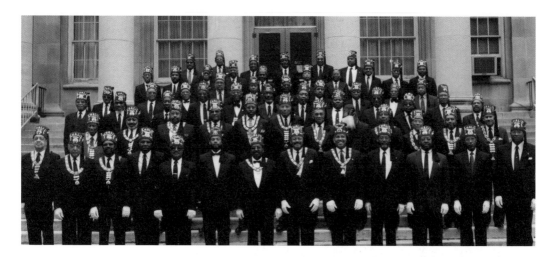

Khalif Temple # 144 celebrated its fiftieth anniversary in 1995. Among the major projects sponsored by this group were donations to Hayes-Taylor YMCA, Khalif's Sickle Cell Golf Tournament and the organizing of the history of Khalif Temple. During the fiftieth anniversary celebration, Ray K. Flowers served as illustrious potentate.

—Ray K. Flowers

Founded in 1935, the National Association of Negro Business and Professional Women's Clubs, Inc. has two active chapters in Greensboro. This nonprofit organization was founded with the purpose of promoting and protecting the interest of women business owners and professionals, as well as providing community service in various capacities.

—Brenda W. Brown

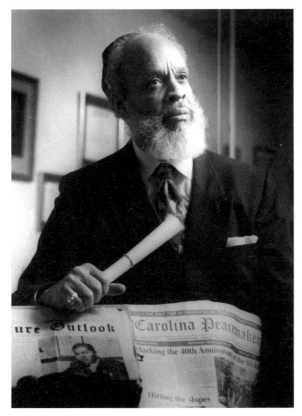

"Dr. K."

Dr. John Marshall Killimanjaro is the founder and publisher of the *Carolina Peacemaker*, Greensboro's African American weekly newspaper. Founded in April 1967, the paper continues to provide community news, sports and entertainment.

His wife Vickie currently serves as the newspaper's associate publisher and daughter, Afrique, is the editor.

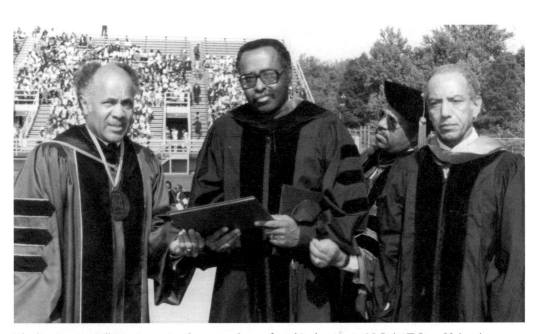

The late Senator Bill Martin receives honorary degree from his alma mater, N.C. A&T State University.

Growing up in a time of Jim Crow laws and segregation, Dr. Alvin V. Blount realized at an early age the necessity of an education. He enrolled at A&T College and graduated with high honors with a BS degree in science.

Dr. Blount was a civic, social, economic and political activist and very involved at A&T. As a student he was a founding member of Alpha Kappa Mu Honor Society, chair of the editorial board for the *A&T Register* and served as president of the Student Government Association. As an alumnus he was the Alumni Investment Control's first chairperson. He served for more than twenty years as N.C. A&T State University's foundation president, where he raised over $26.3 million for scholarships and other support for the university.

Dr. Blount was a litigant in *Simpkins v. Moses H. Cone Hospital*, a landmark decision by the United States Supreme Court that led to the elimination of segregated healthcare.

Patrice A. Hinnant, judge, lawyer and civic leader, became the first woman elected by the Democratic Party as district court judge in Guilford County. A native of Greensboro and a product of the public schools, Hinnant attended Spellman College and N.C. Central School of Law. Other firsts as a black female include assistant public defender, president of the Greensboro Bar Association, president of the Junior League of Greensboro and chair of the United Arts Council of Greensboro. She has served as president of Delta Sigma Theta Sorority, Inc. and is a member of Links, Inc.

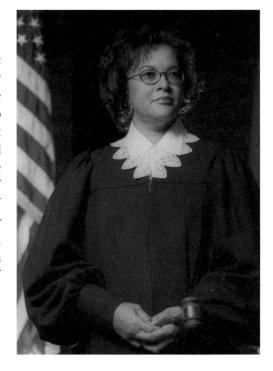

All Nations Evangelical Church.

After many years of outdoor evangelistic services in the streets and low income housing projects in the Greensboro community, Rev. Dr. Albert and Dora Som-Pimpong founded All Nations Evangelical Church. Also known as the "Home of the Heavenly Mart," the majority of the church's members are Africans.

—Rev. Albert Som-Pimpong

Herman, as he was so fondly called, was widely known in civic and community affairs, of which he unselfishly took part. During the civil rights movement of the 1960s, Herman saw a need to dedicate his life to serving others. He was appointed to several boards and commissions.

Realizing the need for representation for all citizens of Greensboro, Herman officially began his political career in 1983, when he was overwhelmingly elected to the North Carolina House of Representatives. Through his voice, he was able to bring millions of dollars to the citizens of Greensboro for projects such as Hayes-Taylor YMCA, the former L. Richardson Hospital and his alma mater, N.C. A&T State University.

Herman was a great believer in the theme: "Let the work I've done speak for me."

—Grace Grant Gist

Herman Gist.

85

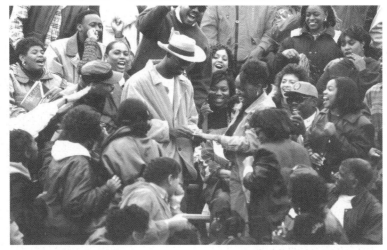

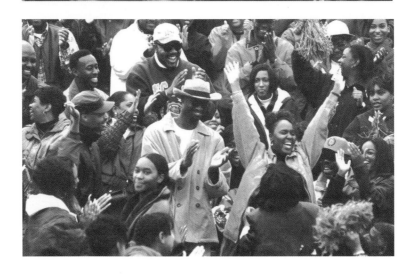

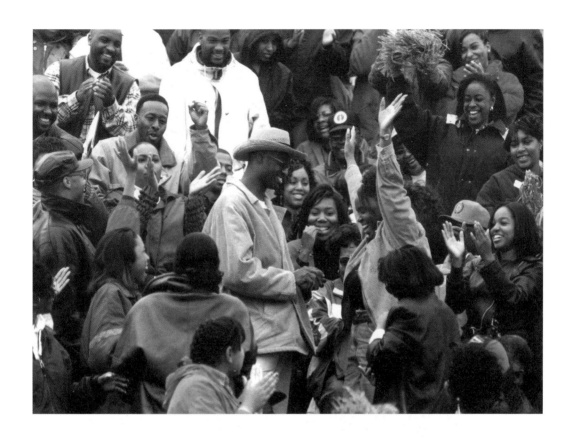

"Will You Marry Me?"

Locust Grove Missionary Baptist Church was organized in 1860, being one of the oldest African American churches in the county. It was organized under the leadership of Rev. Harry Cowan, a former slave. The church school was held in an old log schoolhouse, formerly used by whites. The school was located near a locust tree from which the church got its name.

Since 1868, only ten pastors have served this congregation, the most recent being Alexander O. Walker (pictured below with his wife) and Rev. William G. Hill Sr.

A new fellowship wing was completed in June 2003. It consists of a stage, multipurpose area, state of the art kitchen, office spaces and lounges for men and women. This is the third structure in the history of the church.

—Rev. William G. Hill Sr.

The Top Ladies of Distinction, Inc., is a humanitarian and professional organization whose mission is to serve others through their many different facets. The founding purpose was to sponsor a youth organization after school integration was initiated. Since its founding, the objectives have been expanded to include not only a focus on the youth organization known as Top Teens of America, but also improving the status of women, service to senior citizens, community beautification and community partnership. TLOD supports the NAACP, UNCF and the awarding of scholarships to graduating high school seniors. TLOD has incorporated into its program a cooperative peer education program with the Top Teens of America and the National Foundation of March of Dimes. The Guilford County chapter of TLOD was organized in this area by Rebecca V. Graves in 1986, and received its charter on the N.C. A&T State University. Pictured above are the Top Ladies of Distinction and below, the Top Teens.

—Rebecca V. Graves

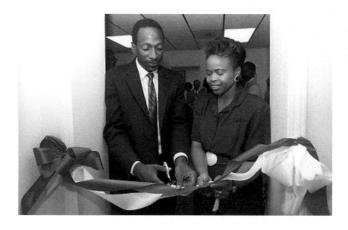

Triad Sickle Cell Anemia Foundation was organized in 1970 by the Les Femmes Social Club. The agency was begun to provide education, counseling, testing and support to persons living with sickle cell disease. The Les Femmes and board members worked closely together to bring celebrities to Greensboro who had invested interest in making sure all persons knew about sickle cell disease and to dispel the many myths that surrounded the condition.

Persons in the picture from left to right are: Lewis Brandon, Gladys Ashe Robinson, Hank Aaron, Kathy Moore Norcott and Karen Jordan.

In collaboration with Duke Comprehensive Sickle Cell Center, a clinic was established for persons with sickle cell disease at L. Richardson Hospital so that individuals would not have to travel to Durham to receive specialized care. After the closing of L. Richardson, the clinic was moved to the Sickle Cell Office.

Pictured are: Dr. George Phillips, hematologist at Duke Comprehensive Sickle Cell Center, and Gladys Ashe Robinson, executive director of Piedmont Health Services and Sickle Cell Agency.

—Kathy Norcott

Carolyn Galloway, member of the Beta Iota Omega chapter of Alpha Kappa Alpha Sorority, Inc. presented a bouquet of roses to Gladys Knight at her performance for the 1983 Aggie Homecoming. Gladys Knight is a member of Alpha Kappa Alpha Sorority, and Ms. Galloway had the honor of making this presentation on her behalf.

—Carolyn Galloway-Randolph

Aggie Homecoming Concert.

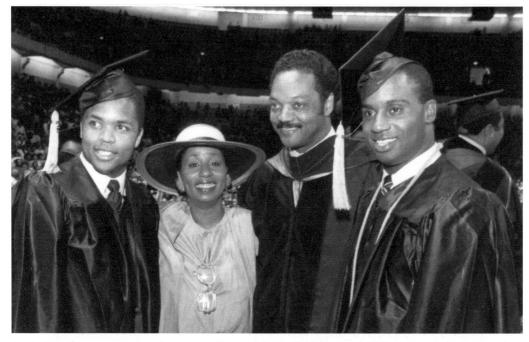

Aggie Commencement: Rev. & Mrs. Jesse Jackson celebrate the graduation of their sons, Jesse Jr. and Jonathan.

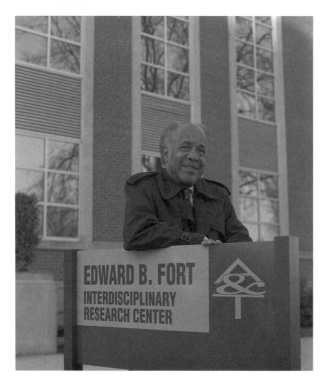

Named in honor of Dr. Edward B. Fort, N.C. A&T State University's seventh chancellor, the Fort Inter-Disciplinary Research Center reminds one of the fact that by 1990 the university, under Fort's leadership, had achieved the distinction of being number three of the sixteen universities of the North Carolina system in research productivity.

Chancellor Fort led the university for seventeen years before retiring in 1999. He led the university in developing the first doctoral program on the campus. His leadership led to much pride among Aggies, which subsequently led to the slogan "Aggie Pride."

Sit-In Movement, Inc.

The Sit-In Movement, Inc. was founded on November 3, 1993, by Earl Jones and Melvin "Skip" Alston, pictured below. Earlier that year the F.W. Woolworth Corporation announced the closing of its downtown store. The purpose of founding the nonprofit organization was to purchase the building and to renovate and convert the complex into the International Civil Rights Museum.

Woolworths was the site of America's lunch counter sit-in, which was initiated by four students from A&T College on February 1, 1960. That one event was credited by civil rights historians and Rev. Martin Luther King Jr. for reinvigorating the civil rights movement.

The organization has an annual awards banquet each year on February 1, and has presented the annual Alston/Jones International Civil Rights Award to individuals who have sacrificed and contributed to civil rights and human rights. Past recipients have included Maya Angelou, Rev. Jesse Jackson, Ambassador Andrew Young, Congressman John Lewis, Rosa Parks and Rev. Al Sharpton.

The museum is tentatively scheduled to open in late 2008 or early 2009.

—Earl Jones

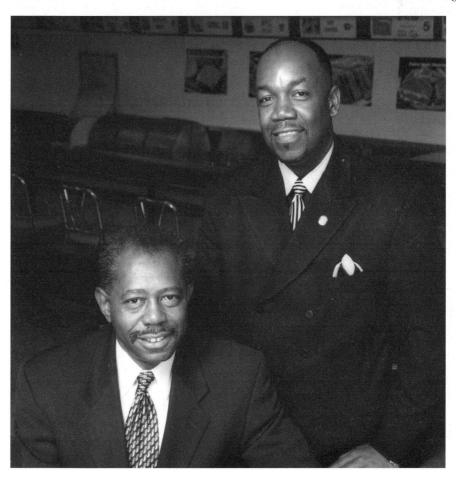

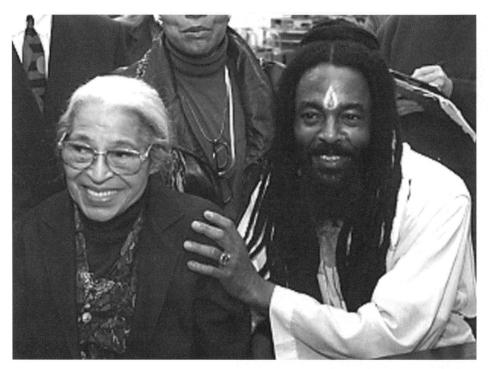

Above: Jibreel Khazan greets Rosa Parks.

Below: Rosa Parks meets a future leader.

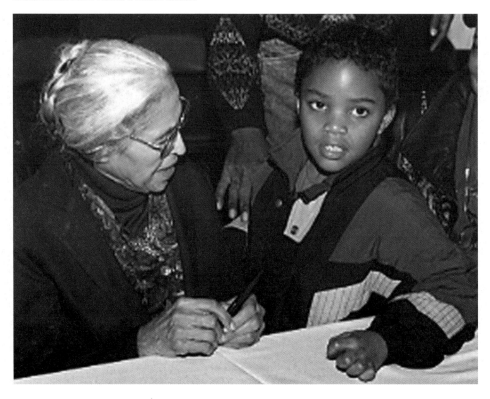

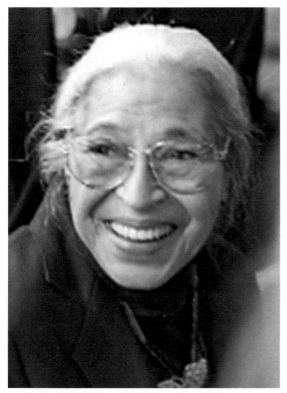

Left: The mother of the civil rights movement: Rosa Parks.

Below: Rosa Parks receives award from Skip Alston (left) and David Richmond Jr.

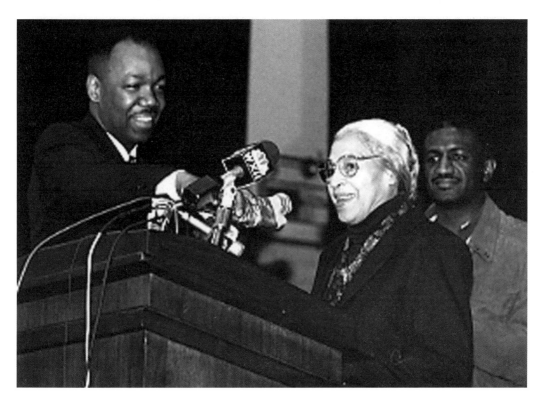

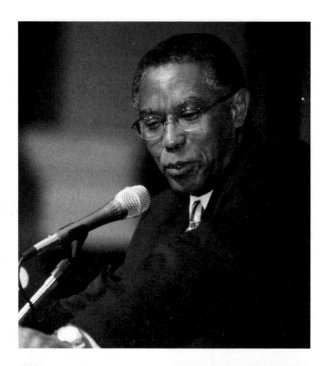

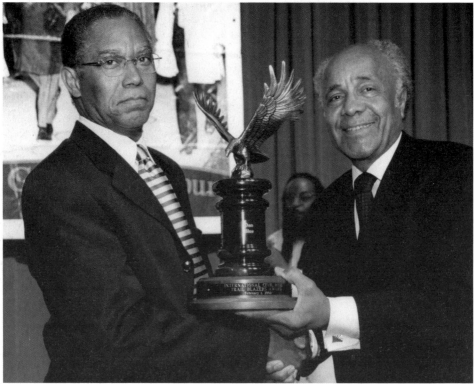

Top: Speaker Dan Blue, former Speaker of the North Carolina House, speaks at banquet.
Bottom: Speaker Blue receives award from Chancellor Fort.

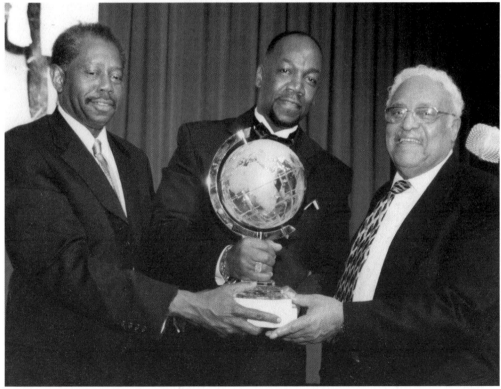

Top: Ben Hooks, former CEO of the NAACP and civil rights leader, leads discussion.
Bottom: Ben Hooks receives Alston-Jones Award.

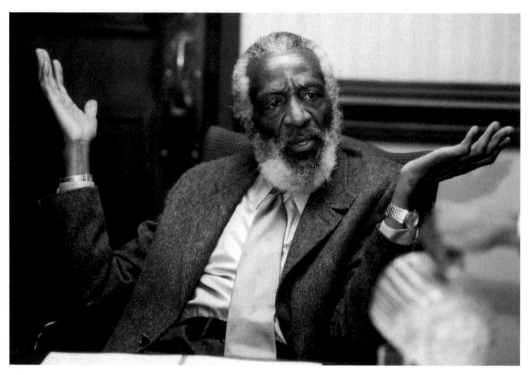

Above: Dick Gregory speaks at a press conference.

Below: Dick Gregory greeted by members of the Greensboro community, Claudette Burroughs–White, Attorney Henry and Mrs. Issacson.

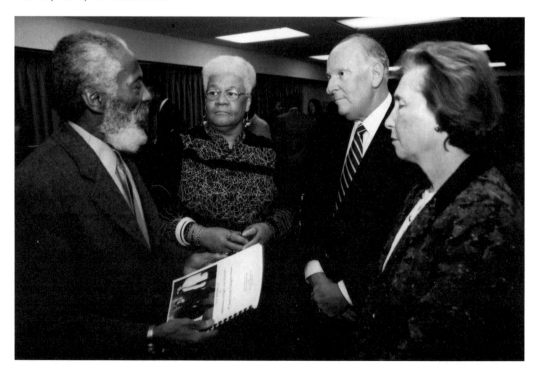

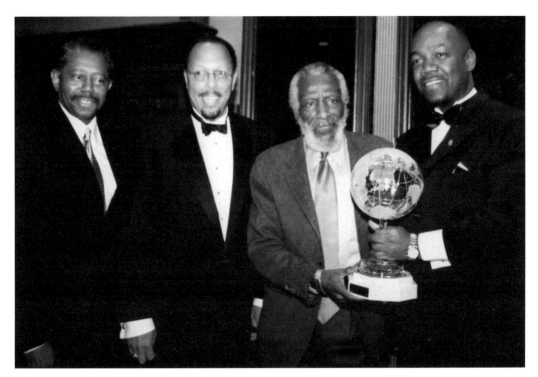

Above: Dick Gregory receives Jones–Alston Award.

Below: "We Shall Overcome."

Above: Graveside memorial for David Richmond.

Below: Joe McNeil, Jibreel Khazan and David Richmond after Project Homestead naming of streets in their honor.

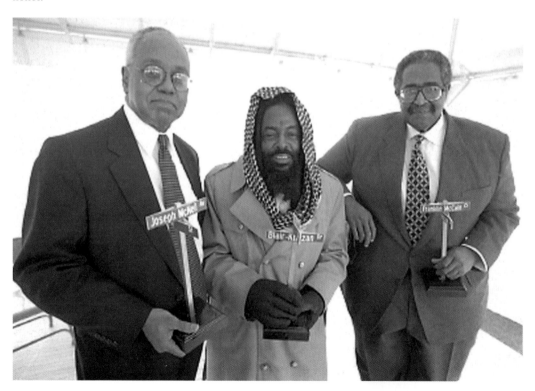

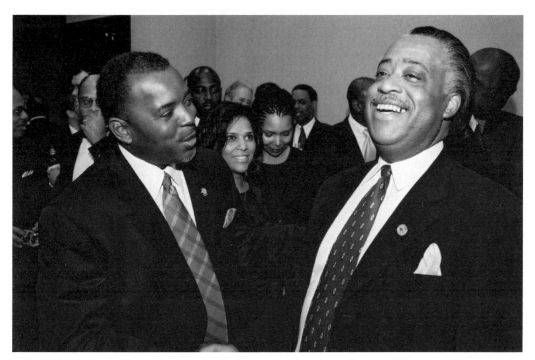

Above: County Commissioner Bruce Davis greets Rev. Al Sharpton.

Below: Rev. Al Sharpton enters banquet as honoree.

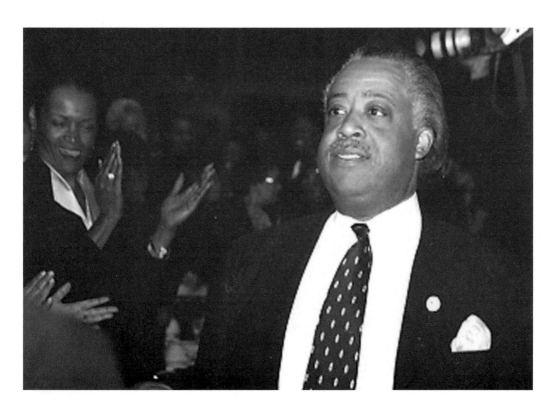

Above: Lillian Harris, philanthropist, receives award from Earl Jones and Skip Alston.

Below: Rev. Sharpton receives award from Chancellor Fort, Earl Jones and Skip Alston.

The Turn of the Century
2000

In 2000 I was thinking of ways to raise funds for the Dudley High School athletic department. I got the idea to have a dinner inviting former athletes. I spoke with former coaches William Boyers, Jonathan McKee and Herbert Meadows. From this conversation the idea of the formation of the Dudley Hall of Fame/Hall of Distinction was started.

With the support of former principal Ken Thompson, Athletic Director Joe Godette, alumni Herbert Jackson, Stahle Vincent, John Harris, Melvin Henderson, Everette James, Otis Hairston, Dale Tonkins and others, we developed the constitution and bylaws. We have given over $10,000.00 in scholarships to Dudley students and inducted over forty outstanding Dudley athletes and outstanding alumni into the HOF/HOD.

—Ray Crosby

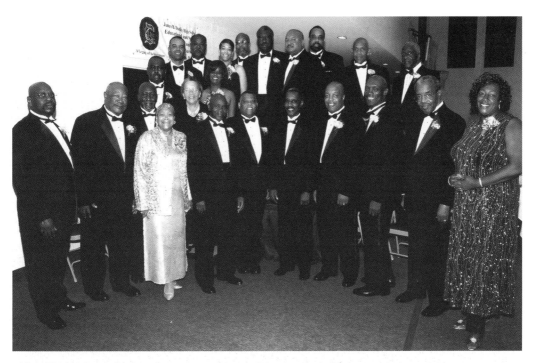

The Hall of Fame/Hall of Distinction Committee.

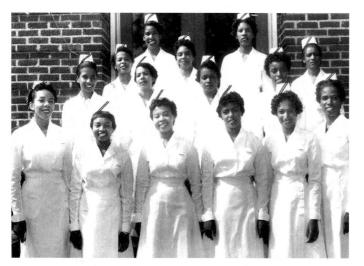

As a pioneer of the first graduating class of the School of Nursing at A&T College in 1957 we experienced a vigorous curriculum and a variety of teaching methodologies that were used to assist students in acquiring knowledge and obtaining nursing skills. It was well understood that high standards in behaving, performance and appearance would not be compromised.

The A&T Nursing Class of 1957. *Courtesy School of Nursing.*

The first graduating class was assigned during segregation in a predominately white hospital where all aspects of patient care and facilities used by students had to be above reproach. The instructors monitored all aspects of the nursing profession and were excellent role models.

We gathered in 2003 to celebrate the beginning of the nursing program at A&T in 1953. Being the first class to graduate from the program brought much pride to those in the class of 1957.

—Delores Estes '57

"Aggie Nursing Reunion." Pictured is the A&T College Nursing Class of 1957.
Courtesy School of Nursing.

"We Shall Keep the Spirit Alive."

Immanuel Lutheran College was an important part of our foundation. Even though she closed in 1961, she is not gone as long as we exemplify and pass on to others what we learned at our beloved school. Our times together at our reunions are nostalgic as we remember many happenings. Immanuel is still loved in our minds and hearts, and we strive to remember our commitment to the lordship of Christ and to each other.

—Anita Harris Bailey-Blanks '45 and '47

Carolyn Coleman was the first African American woman to serve as special assistant to Governor James B. Hunt Jr. and the first African American woman to chair the Guilford County Commissioners. She led the North Carolina NAACP in its efforts to eliminate the at-large method of electing public officials, making possible the election of ten African American Superior Court judges, hundreds of African American city council members, county commissioners and school board members.

—Thomas J. Scott Sr.

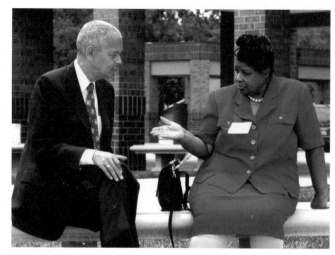

Carolyn Q. Coleman.

Drs. Rashad and Cosby.

Dr. Johnetta B. Cole, Bennett College for Women president, and Deborah Tillman Love, vice-president of the Bennett College National Alumnae Association, greet Dr. Phyllisha Rashad and Dr. Camille Cosby, two of the recipients of the Doctorate of Humane Letters bestowed by the college. Dr. Rashad also served as the commencement speaker. Dr. Rashad is a Tony Award-winning actress who is best known for her portrayal of Claire Huxtable on the long running series *The Cosby Show*. Dr. Cosby is a philanthropist and educator. She is the wife of actor and comedian Bill Cosby.

—Deborah Love

Lady Sertoma of Greensboro sponsored "Distinguished Young Men-Greensboro's Finest" in 2005. These young men, ages 10–14, were nominated by Lady Sertoma members. They were provided special training in proper etiquette, self-control and discipline. Overall they gained a deep appreciation for their own self-worth. They are pictured participating in the Martin Luther King Parade.

—Shirley McFarland

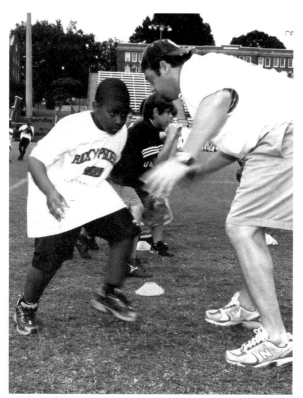

Ricky Prohel Football Camp is a fun learning experience for almost all kids that enjoy the game of football and would like to learn the game from tackling to running plays in games. Here I am seen learning to come off a three point stance against three-hundred-pound offensive lineman Todd Fordham of the Carolina Panthers. We had the privilege of training with these real professional football players from the Carolina Panthers. I am sure that is an experience that most of the campers will never forget.

—W. Sidney Hairston

Prohel Football Camp.

Joey Cheek, a Dudley High School graduate, was honored by the City of Greensboro for his achievements as a gold medal winner in the 500-meter speed skating event at the 2006 Winter Olympics.

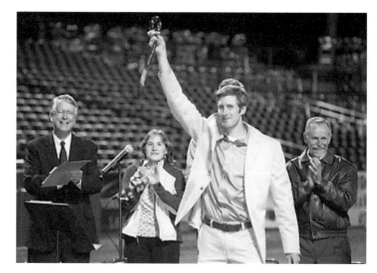

"Joey Cheek Day."

Rev. Dr. Mazie Ferguson (right).

God inspires within me an urgency to pursue a life journey that makes a difference. As an African American female, I have been challenged but blessed to break through gender barricades and rise above the elusive stained-glass ceiling. God empowers. Horizons beckon. Against the dialectical tension between maintaining status quo in gender, race and class; and pressing for equitable distribution of privilege, I work with fever and integrity toward equity for all. As a theologian by calling and student of jurisprudence by profession, I am convinced that humanity must move to a higher plane. God calls. Life answers. My journey continues.

—Mazie Ferguson

Upon moving to Greensboro, North Carolina, Joseph Wilson Mitchell served on boards, in leadership roles, or as a member of local organizations for which he received numerous honors and awards. He served faithfully in the NAACP for almost forty years and was instrumental in generating funds for the support of the local and state branches. He was the first fully paid life member and Golden Heritage member of the Greensboro branch of the NAACP.

As a community activist, Joe participated in a landmark lawsuit against P. Lorillard Tobacco Company to ensure that African Americans could have equal employment opportunities. During the civil rights movement of the 1960s, he participated in the sit-ins in Greensboro and was jailed on one occasion.

—Kathleen Mitchell

Back-to-back state championships, 2005–2006.

Anytime a team, coaches, schools and communities can win a state championship, it is a thrill and a blessing. When Dudley High School won the State 4-A championship basketball title in 1996, after a significant stretch of time, the bar was raised to keep it up. Finishing as runners-up in 2000 and 2004, the 2005 and 2006 state titles were very sweet for everyone involved.

—Coach David Price

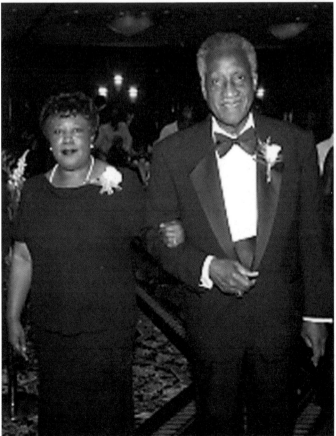

Bishop Cecil Bishop was elected the seventy-eighth bishop in the line of succession of the African Methodist Episcopal Zion Church at the forty-first session of the Quadrennial General Conference of the AME Zion Church meeting in Greensboro in 1980.

He pastored Trinity AME Zion Church from 1960–1972. He provided leadership during the civil rights movement in the 1960s which led to peaceful, nonviolent integration of public accommodations in the city.

He was retired at the forty-seventh session of the Quadrennial General Conference also meeting in Greensboro in 2004, after serving twenty-four years and reaching the status of senior bishop of the denomination.

—Rev. Michael A. Frencher

The Legacy of Johnnetta B. Cole

Dr. Johnnetta B. Cole: Exuberance.

In 2002 Bennett College was blessed with the appointment of Dr. Johnnetta B. Cole as its fourteenth president. During her five-year tenure, the college was revitalized by record enrollment increases, extensive campus renovations, increased scholarship support for students and the completion of a fifty million dollar capital campaign. Dr. Cole was also able to draw many nationally known figures to Greensboro and to Bennett. Some of the best known persons to come to Bennett included Mrs. Coretta Scott King, Rev. Jesse Jackson, Susan Taylor, President Bill Clinton, Senator Bob Dole, Bill Cosby and Oprah Winfrey. Many of these figures are pictured here.

—Arthur G. Affleck III

A gala evening with comedian actor Bill Cosby.

Former Bennett president Dr. Issacc Miller greets Rev. Joseph Lowery.

Mutual Respect: Dr. Maya Angelou and Dr. Johnnetta Cole.

President presents: Rev. Jesse Jackson.

Rev. Jackson posing with Bennett College alumna Wanda Mobley and *Carolina Peacemaker* publisher Vickie Kilamanjaro.

Above: Ashford and Simpson embrace Dr. Cole.

Below: President presents: Judge Glenda Hatchett.

Above: President presents: Ambassador Andy Young.

Below: Ambassador Young posing with his admirers.

Above: President presents: Sonia Sanchez.

Below: President presents: Mrs. Coretta Scott King as she poses with a group of young admirers.

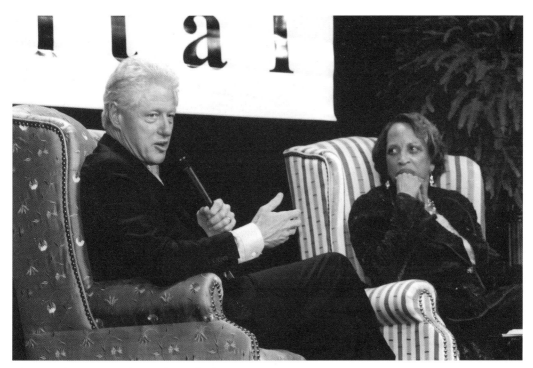

Above: A gala evening with President Bill Clinton.

Below: Senator Bob Dole receives gifts from Bennett College students.

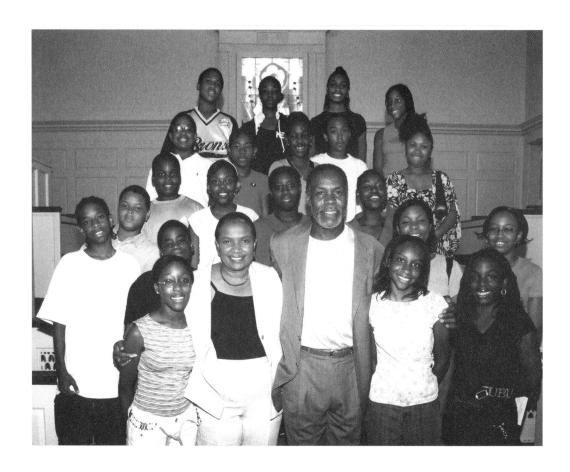

Principal M. Thompson and her students from Otis L. Hairston Middle School pose for a picture with actor Danny Glover on the campus of Bennett College. He was a featured guest during Bennett's President Presents series. The students were enthralled to be in Glover's presence. Mr. Glover challenged the students to examine carefully the United States foreign policies directed toward Africa and Diaspora in the Caribbean…this was an educational and memorable day for the middle school students.

—Margie Y. Thompson

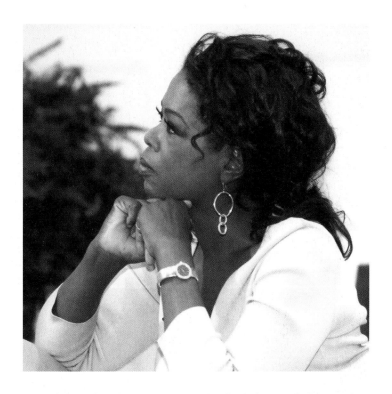

During my matriculation at Bennett College for Women, I must say that Dr. Johnnetta Cole exposed us to some amazing men and women. Of course, Ms. Oprah Winfrey was one of those amazing people. She inspired us, challenged us and most importantly shared her wisdom with us and I will always hold the gracious gift deep in my heart.

—Sharrelle Barber

Fifteenth president of Bennett College for Women, July 2007. Dr. Malveaux (center) being greeted by Bennett Alumnae.

What I want for Bennett College for Women is what I would want for every young woman. I want this to be an oasis for African American Women. A place where we are celebrated and educated.

—Julianne Malveaux, PhD

Chancellor Stanley Battle (right) receives the torch from interim Chancellor Lloyd Hackney as A&T's ninth chancellor.

"I do not know whether Stanley Battle is a man for all seasons, but I do know he is the man for this season. I pass the torch with no reservations, no reluctance."

Chancellor Battle: "We're going to start early and finish late. Our work ethic is all we have. I have waited for this opportunity all my life."

About the Author

Otis Hairston's decades of photography present an ongoing memory of Greensboro African Americans celebrating, demonstrating, organizing, acting as community heroes and welcoming visiting national celebrities. It is a nostalgic look at the historic celebrations of the famous Aggie Homecoming weekends of the '70s, the anniversaries of the Greensboro Four in the '80s, the vision of the opening of the International Civil Rights Museum in the '90s and the legacy of Dr. Johnnetta Cole's revitalization of Bennett College as a new century challenged the Greensboro community.

For almost forty years, Hairston not only documented much of the history of his hometown of Greensboro, North Carolina, but his photographic assignments also took him to countries such as Nigeria, where he photographed Shagari and Pope John Paul II.

Hairston has photographed hundreds of national and international personalities, politicians, writers, actors, athletes and educators, including President Jimmy Carter, Rev. Martin Luther King Jr., Rev. Jesse Jackson, Nelson Mandela, Coretta Scott King, Maya Angelou, Stevie Wonder, Shirley Chislhom, Arthur Ashe, Oprah Winfrey, President Bill Clinton and actress Cicely Tyson.

He has been an assignment photographer for *Ebony* magazine, as well as photographer for educational institutions such as Bennett College and North Carolina A&T State University. In addition to shooting portraits, Hairston has also traveled throughout this country and abroad, capturing the beauty of the earth and sky in landscapes.

Visit us at
www.historypress.net